PAST & PRESENT

LOS ANGELES RAILWAY

OPPOSITE: David Hutchinson (pictured) ran the Cummings Street (horsecar) Line between Hollenbeck Park and the Sisters' School with a connection to First Street in this c. 1896 photograph. There would be some interim changes from its opening in 1887 to 1898, when the Los Angeles Railway would eventually become the new owner and "electrize" [*sic*] the route. (Courtesy Mount Lowe Preservation Society [MLPSI], E. Rod Crossley Collection.)

LOS ANGELES RAILWAY

Steven J. Crise, Michael A. Patris,
and the Mount Lowe Preservation Society

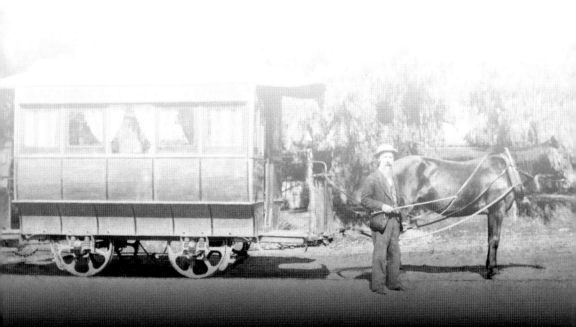

To our mothers, Shirley Ann Crise and Joanne Bartha, who were constant sources of love, encouragement, and inspiration throughout their lives

ISBN 978-1-4671-0588-0

Library of Congress Control Number: 2021935875

Published by Arcadia Publishing
Charleston, South Carolina

Printed in the United States of America

For all general information, please contact Arcadia Publishing:
Telephone 843-853-2070
Fax 843-853-0044
E-mail sales@arcadiapublishing.com
For customer service and orders:
Toll-Free 1-888-313-2665

Visit us on the Internet at www.arcadiapublishing.com

ON THE FRONT COVER: Iconic Los Angeles City Hall frames this 1963 photograph as car 3161 heads east into Little Tokyo along the P-Line. Generations of streetcars were on the edge of extinction as bus service became the new normal. Metro Local bus 5029 runs Route 30, and light rail is making a comeback in LA. (Past photograph by Donald Duke, courtesy Golden West Books [GWB]; present photograph by Steve Crise.)

ON THE BACK COVER: Two unidentified Los Angeles Railway employees, a "conductorette" and a "motorman," pause on the U-Line. Women first began piloting streetcars for the Los Angeles Railway in 1918, when the Spanish flu pandemic and World War I created a shortage of operators. During World War II, as many as 300 women filled the control seats of streetcars and buses. (Photograph by Ivan Baker, courtesy Craig Rasmussen.)

CONTENTS

ACKNOWLEDGMENTS

There are many accommodating individuals who facilitated the creation of this visual history of the Los Angeles Railway (LARY) and its successor companies. While it's not possible to acknowledge them all, this is our valiant attempt to do so. The late Jack Finn and his Pacific Electric Railway Historical Society Archives (peryhs.org) were the basis for an ever-increasing collection of materials on both the Pacific Electric (PE) and the LARY. Our fervent wish is that Jack's work should live in perpetuity through our nonprofit Mount Lowe Preservation Society (mountlowe.org), to which he donated his life's work.

Photographer and friend Alan Weeks's enormous body of material is matched by his generous propensity for sharing knowledge and photography of days past and Southern California railroading history. Alan rode the streetcars and buses and then worked for and retired from the Southern California Rapid Transit District (SCRTD). Our great friend, historian, and archivist Craig Rasmussen freely shared images and knowledge from his own estimable collection. Historian and archivist Anne Collier is our go-to colleague for finding the most obscure information in the most mystical ways. She must have lived three lifetimes to have such encyclopedic knowledge. Jim Bunte has provided years of friendship, design, layout, and IT for our nonprofit projects. Valued friend Cay Sehnert has also been a faithful editor. Thanks are also due to longtime friend Ralph Cantos, Harvey Laner, Bill Bradley, Mark Effle, Robert C. Post, George W. Hilton, Paul Smedley, Andy "AJ" Chier, Andres DiZitti, Dave "Pookie" Edwards, Terry Hamilton, and Caitrin Cunningham.

Those now gone who were invaluable include Shirley Anne Crise for her 37 years with the LAMTA, SCRTD, and LA Metro; Donald Duke; E. Rod Crossley; Malcolm "Mac" McCarter, whose archives were donated by his daughter Susan Chester; John F. Bromley; Jim Walker; Edmund Kielty; Marvin "Bill" Whyte; and Jim Kreider, who donated the photographs of Bruce Ward.

Helpful institutions include the Mount Lowe Preservation Society, the Pacific Electric Railway Historical Society Archives, the Steve Crise archive, the Michael Patris Collection at mountlowe.org, John Cahoon of the Natural History Museum of Los Angeles County's Seaver Center for Western History Research (SCWHR), Jim Harder at Rio Vista Trolley Museum/Western Railway Museum, Pacific Railroad Museum, and Terry Salmans at Southern California Railroad Museum.

Finally, thanks to our wives, Yoko Mazza and Mudd Patris, for tolerating our one-track minds.

All modern images were created by and are the sole property of photographer Steve Crise (scrise.com).

INTRODUCTION

Thirty-seven years after California was granted statehood, the Los Angeles City Council passed the first streetcar franchise ordinance on July 3, 1873. The following year, the Spring & Sixth Street Railroad Company began operation with equines as motive power. Multiple franchise expansions were planned, and the need to connect with other streetcar lines or railroads like at Southern Pacific's Arcade Depot became evident within a year. As technology progressed and competition grew, the Second Street Cable Railway Company operated as the first cable car system in Los Angeles in 1885. It was modeled after San Francisco's famed cable cars, with a cast iron gap in the street where a motor-driven cable ran underground to transport the motorless cars along the line. The Second Street Cable Railway's route ran only 1.25 miles, being intentionally short for specific neighborhood passenger service.

In 1887, the Los Angeles Cable Railway (LACR) incorporated and launched a plan for buying existing lines and linking them together; it also created lines from scratch and expanded connections to unify the system. The railway reached as far as Westlake Park, East Los Angeles, Boyle Heights, and nearly all the way to Agricultural Park near the current-day University of Southern California and LA Metro's light rail Expo Line. But after growing too quickly and facing a national recession, the LACR sold out to a Chicago group that formed the Pacific Railway Company (PRC) in 1888. The PRC improved lines and infrastructure but suffered from wary investors, lack of funds, and over-expansion. Also in 1887, the Los Angeles Consolidated Electric Railway Company (LACE) became the first electric streetcar company in Southern California, created in part to move prospective real estate customers to a subdivision on Pico Street. With electricity being new technology, the explosion of a power station and other setbacks pushed the public back again toward cable car technology, in which substantial investments had been made.

Throughout the 1890s, there were more streetcar companies on paper than had actually laid tracks, and of the many that had, several had failed. Consequently, some city leaders and citizens considered trolley bonds worthless. In 1892, open discussions began between the formerly competing Los Angeles Consolidated Electric Railway Company and the Pacific Railway Company. Within a year, LACE had acquired all the lines of the PRC, yielding 90 percent control of the entire Los Angeles area's streetcar traffic. Months later, LACE, with the Pacific Cable Railway assets, also had financial trouble and failed to make bond payments, forcing a bondholder takeover. In the meantime, another competitor, the Los Angeles Traction Company (LATC), began building a system linking numerous franchise extensions to its network, including the Santa Fe Railroad's La Grande Station, which became operational within a few years. Controlling interest in LATC was then sold to the Southern Pacific Railroad, founded in 1865 and having access to the intelligences of the "Big Four" (Charles Crocker, Leland Stanford, Mark Hopkins Jr., and Collis Huntington).

In 1895, the Los Angeles Railway (LARY) was born from the bondholder takeover of LACE company assets, combined with the properties of the Pacific Cable Railway. This new conglomerate was tasked with combining numerous lines into one enterprise and standardizing the track to a narrow gauge of three feet, six inches to initially serve the

central Los Angeles area. By mid-1896, the task was completed. Historian and author Paul Smedley (Huntington Tracks, Golden West Books) points out that Henry Huntington might have been doing some strategic planning by stepping away from his board position at the Southern Pacific and also as assistant to his uncle Collis, as he then purchased controlling interest in LARY stock. In 1899, Henry Huntington organized the Pacific Electric Railway. By 1900, Collis Huntington would be dead, leaving numerous parties to scramble to control all rail activity in and out of Los Angeles.

In the new century, the Los Angeles Railway was still expanding and operating over 100 miles of narrow-gauge track, with electric cars heading out on 20 separate routes, having taken over, among others, the old Mateo Street & Santa Fe Avenue Railway and the Cummings Street Line. Henry Huntington was seeking complete control of his railroading empire in Southern California. But following Collis's death, Edward H. Harriman took control of the Southern Pacific Railroad (SP). By 1903, Harriman managed to purchase a 45 percent share of PE stock from Henry Huntington's former partner, Isaias Hellman, who believed Huntington was expanding too rapidly and was doomed to fail. Squabbling became costly, and ultimately Huntington had to go to Harriman to make a deal, which gave the SP a half-interest in the LARY but allowed the PE to continue to expand without SP interference. It was not until 1910 that Huntington gave up his PE shares to the SP in exchange for sole ownership of the LARY.

The Los Angeles Railway would continue expanding until it peaked in 1924 with more than 400 miles of track. It carried more passengers than the Pacific Electric, due to the close-knit proximity of stops in the city versus the extended interurban lines of the PE. Eventually, the LARY would go as far west as the Hancock Park area, south to Hawthorne, north to Eagle Rock, and east to East LA. Expansion included buses with the 1923 formation of the Los Angeles Motor Bus Company, which was a joint venture between the LARY and the PE.

In 1943, the Los Angeles County Regional Planning Commission adopted a resolution for a freeway system for automobiles, giving independence to folks with a desire to roam off the beaten tracks. By 1945, the Los Angeles Motor Bus Company (which became the Los Angeles Motor Coach Company and later Los Angeles Transit Lines [LATL]) partnered with the PE. That same year, 18 years after the death of Henry Huntington, his estate sold the Los Angeles Railway to National City Lines (NCL), which had earlier given LATL its new moniker.

NCL was a conglomerate of companies purchasing streetcar lines around the country and replacing trolleys with more modern and less costly gasoline and diesel buses. This is where the birth of the great streetcar conspiracy began. General Motors, Firestone Tires, Standard Oil of California, and Phillips Petroleum were tried and convicted of monopolizing the sale of buses and supplies to National City Lines under Section One of the Sherman Anti-Trust Act. A relatively small fine was paid, and NCL continued to operate various systems around the country. However, it is important to understand that this streetcar conspiracy did not have any effect on the PE's "Red Cars." The PE had buses since 1902, had been owned outright by the SP since 1911, and continued to operate as a freight hauler, even after passenger service was leased out to other operators such as the Metropolitan Coach Lines, starting in 1953.

In 1958, the Los Angeles Metropolitan Transit Authority (LAMTA) was formed, putting all electric streetcar, interurban, and bus lines under the control of a single agency. It was this quasi-governmental origin that gradually replaced all of the city's streetcar lines with buses until the last run on Sunday, March 31, 1963. After a 27-year absence, light rail returned to Los Angeles with the opening of the Los Angeles Metro's Blue Line in 1990.

CHAPTER 1

HAY, STEEL, AND SPARKS

THE EARLY YEARS

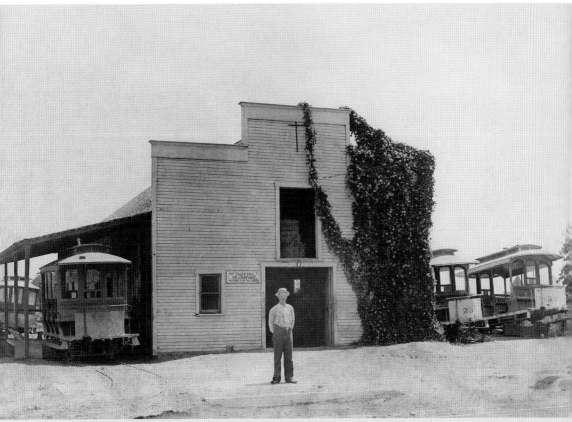

Incorporated in 1887, the Mateo Street & Santa Fe Avenue Street Car Company began as a horsecar line. It was "electrized" [sic] in 1896; sold to Abbott Kinney, who installed a steam dummy; and then sold again to the Los Angeles Railway by 1900. Foreman E.H. Mason poses before electrification. (Photographer unknown, courtesy MLPSI, E. Rod Crossley Collection.)

The Second Street Cable Railway opened in 1885, Los Angeles's first. It ran 6,940 feet between Second and Spring Streets, then west to Belmont Avenue at a 27.7 percent grade, the steepest US cableway. By 1890, flooding and a recession brought failure, but the Pacific Electric Railway retained the western portion. The modern photograph was taken at West Second Street and Boyleston Street looking northeast. The property is now the Department of Water and Power. (Photographer unknown, Courtesy GWB, Donald Duke Collection.)

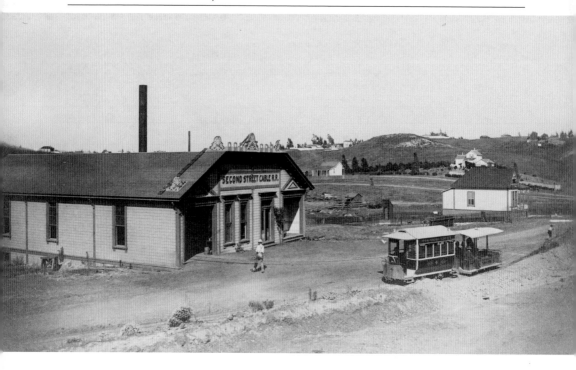

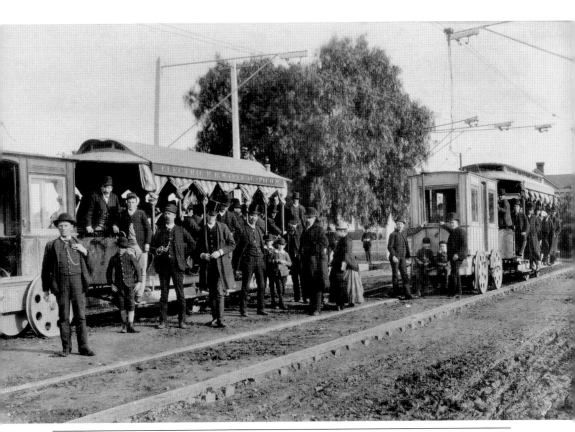

With much fanfare, the Los Angeles Consolidated Electric Railway Company (LACE) Pico Street Line opened on January 4, 1887, as the first electrified route west of the Mississippi. Time has lost the names of those in this photograph, and history remembers the line as a failure due to the explosion of a boiler used to create electricity. Operations ceased on June 8, 1888. This area today is a main transit hub for the Metro and others. (Courtesy MLPSI, E. Rod Crossley Collection.)

HAY, STEEL, AND SPARKS: THE EARLY YEARS

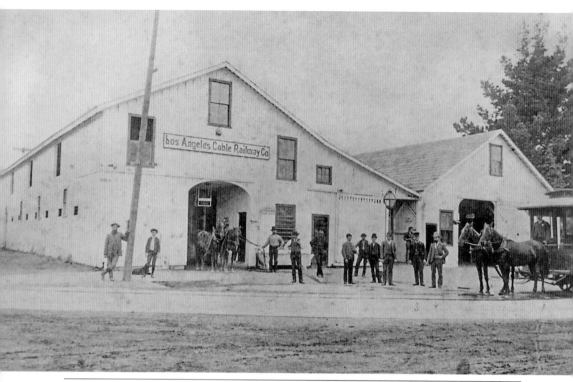

The Los Angeles Cable Railway Company, patterned after San Francisco's Market Street Railway, owned about 20 miles of cable car and horsecar lines as in this photo from 1889. The barn at Twelfth and Olive Streets served as a hub to run equipment on Broadway (formerly Fort Street) to East First Street to Boyle Heights, Broadway to Seventh, and then west to Westlake Park. The Metro Local buses run in this same area today. (Courtesy MLPSI, Michael Patris Collection.)

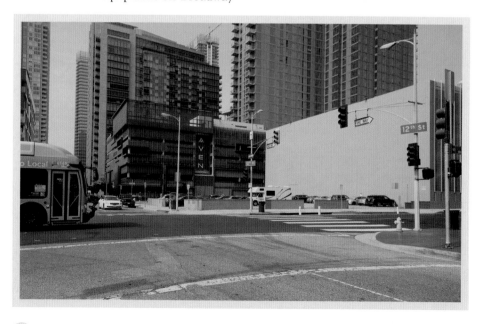

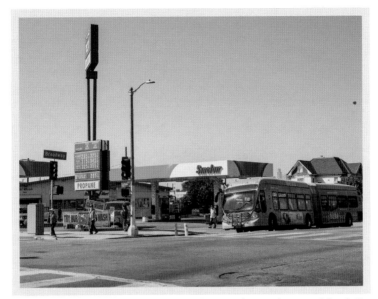

Cable railways became a maintenance nightmare in Southern California. The cement channels in the ground constantly filled with water and flood debris. This 1889 Los Angeles Cable Railway photo was taken at Downey Avenue and Hanson Street. Foreman Ira Tilden stands second from right. Today, it is North Broadway at Eastlake Avenue. Broadway east of the Los Angeles River became North Broadway. Note the Metro articulated bus adjacent to Sinclair Gasoline. (Courtesy Golden West Books, Donald Duke Collection.)

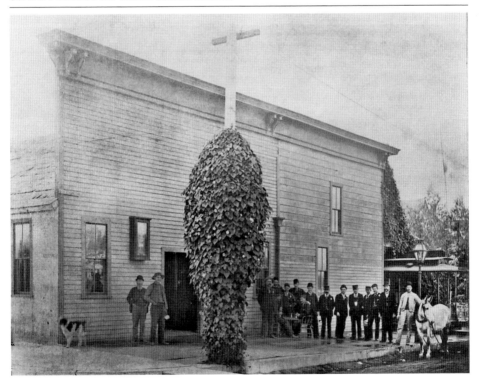

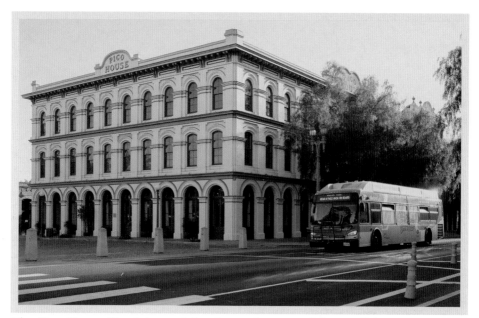

The Pico House Hotel (named for the last Mexican governor of Alta California) opened in 1869, predating any streetcars by five years. Upon opening in 1874, the Sixth & Spring Street Railroad Company began servicing this area, where the hotel was one of its stops. Metro still brings passengers to Olvera Street, and the hotel is now California Historical Landmark 159. The actual address is 430 North Main Street. (Courtesy GWB, Donald Duke Collection.)

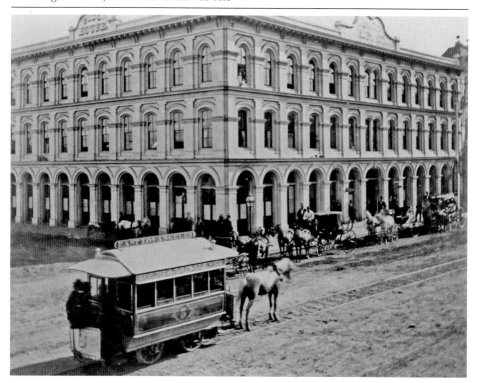

HAY, STEEL, AND SPARKS: THE EARLY YEARS

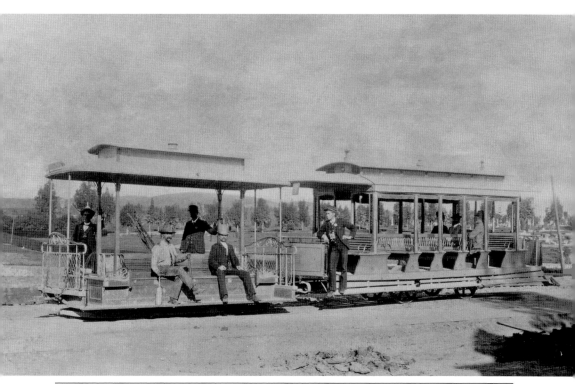

When the Los Angeles Cable Railway began operations in 1889, the Evergreen Cemetery at First Street and Evergreen Avenue had already been open a dozen years. Promoters Isaias Hellman and James Crank ran out of money following overexpansion. Chicago City Railway organizer Charles Holmes purchased 75 percent of the concern and reorganized it as the Pacific Railway (PR). By 1895, Holmes, too, had lost everything, and the PR became part of the LARY. The LAMTA still utilizes this route. (Courtesy SCWHR.)

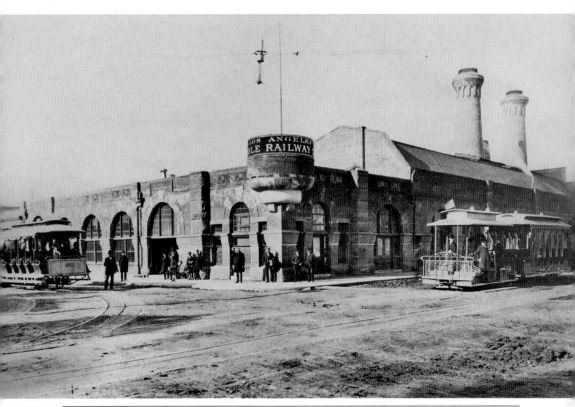

The Los Angeles Cable Railway built its main powerhouse at Grand Avenue and Seventh Street. This 1890 photograph shows diverging tracks from the Agricultural Park and Westlake Park lines. The building today dates from 1925, when J.W. Robinson's Department Store made this its flagship location. By 1934, the building received this art deco facelift, and after a merger with Macy's, the company closed its doors in 1993. The building is once again undergoing renovations. (Courtesy MLPSI, Michael Patris Collection.)

HAY, STEEL, AND SPARKS: THE EARLY YEARS

The Los Angeles Cable Railway at Downey Avenue and Alta Street (now North Broadway and Alta Street) was the eastern extension of the line. Destinations included other depots and connections like the Los Angeles & Redondo Railway, the Southern Pacific Railroad, the Santa Fe Railroad, and the Los Angeles Pacific Railroad. An articulated Metro Rapid bus servicing Line 45 pauses in front of modern-day Abraham Lincoln High School. (Courtesy MLPSI, Michael Patris Collection.)

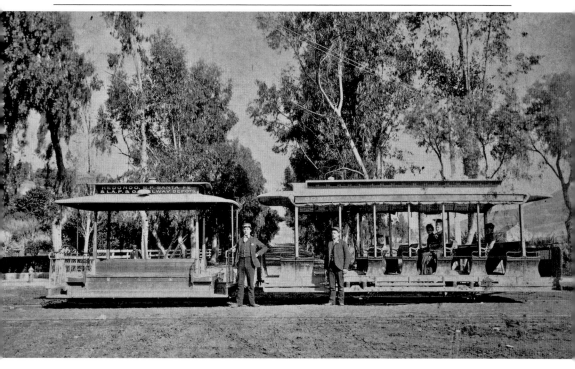

In 1891, the Los Angeles Consolidated Electric Railway Company's University Line ran south on Flower Street at Pico Boulevard toward the University of Southern California. Christ Episcopal Church is on the right. Today, Metro runs some buses on Line 460 to Disneyland along part of the same route. In the center, the Santa Monica–bound train will run similarly on the Expo Line passing USC. The inbound train on the right side will be heading to Union Station. (Courtesy Craig Rasmussen collection.)

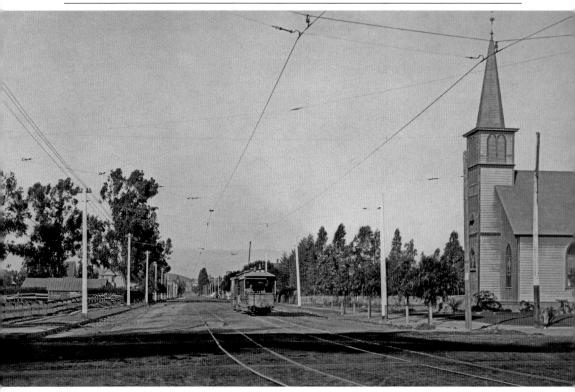

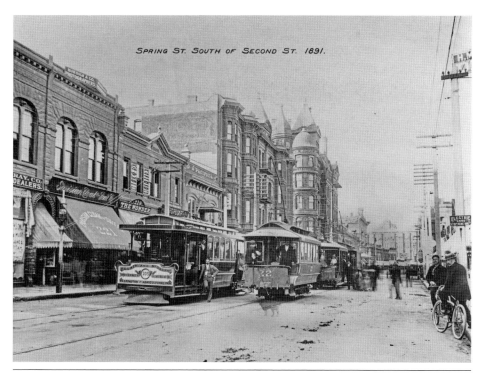

SPRING ST. SOUTH OF SECOND ST. 1891.

As the Los Angeles Consolidated Electric Railway continued to grow, several cars would end up in the same blocks at the same time, as in this photograph on South Spring Street at Second Street in 1891. Today, it is still a mass transit corridor, to which the Metro Rapid Line 45 articulated bus attests. The digital sign atop the bus reads "Go Dodgers!" in advance of their World Series win on October 28, 2020. (Courtesy Craig Rasmussen collection.)

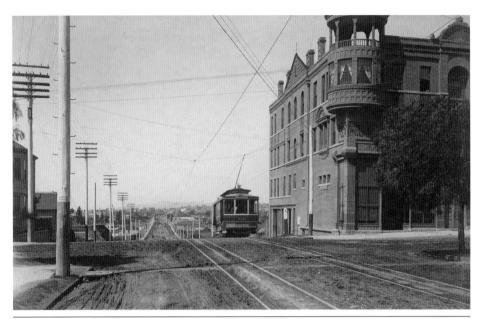

Early stages of the LARY shared assorted street trackage configurations, as shown here with car 149 at First Street and Boyle Avenue in 1895. An electric trolley temporarily ran on obsolete cable car tracks, as multiple lines were cobbled together while mergers and buyouts evolved. Decades later, Metro bus 5079 on Line 30 heads to Indiana Station on a similar route, passing the historic Boyle Hotel, which opened in 1889. (Ward Kimball Collection, SCRM, courtesy John Smatlak.)

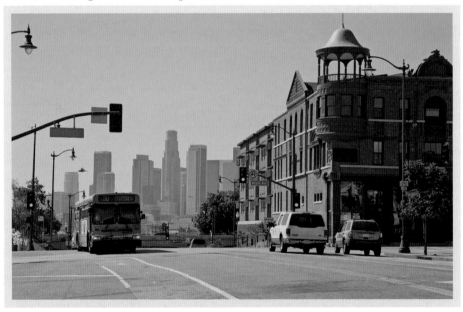

Photographed in 1888, Second Street Cable Railway car 1 serviced the area of Bunker Hill, which was home to many of the wealthiest residents. Flooding and poor drainage of the cable conduit destroyed equipment, closing the line by October 1889. Today, while there is no bus service on Second Street, South Broadway is serviced by Metro buses like 5079. The new highrises in the distance are bound to be luxury condominiums. (Courtesy SCWHR.)

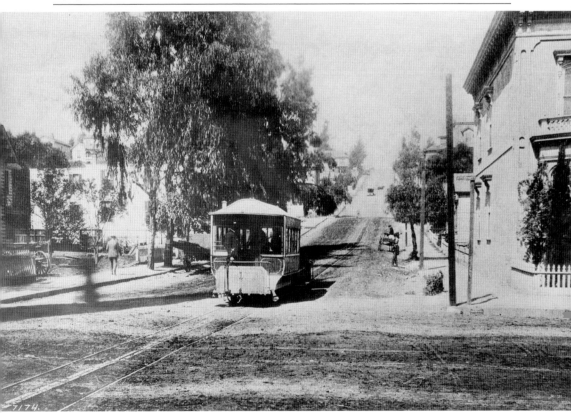

The Los Angeles Traction Company was three years old when it ran this car at Third and Hill Streets in 1898. That same year, the LARY would buy it out on the same day Henry Huntington acquired controlling interest of LARY stock, immediately upgrading the entire system. While this right-of-way did not become LARY trackage, it did remain serviced by several buses, as it is today by this Montebello Bus Lines bus. (Courtesy Craig Rasmussen collection.)

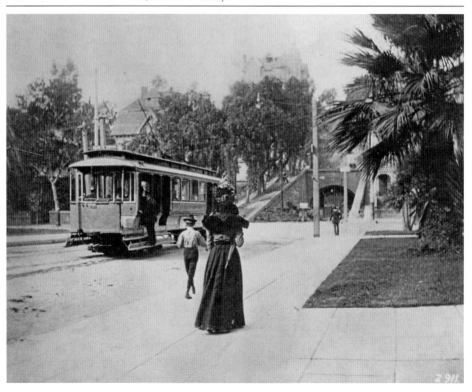

Hay, Steel, and Sparks: The Early Years

E Pluribus Unum

Huntington Builds an Empire

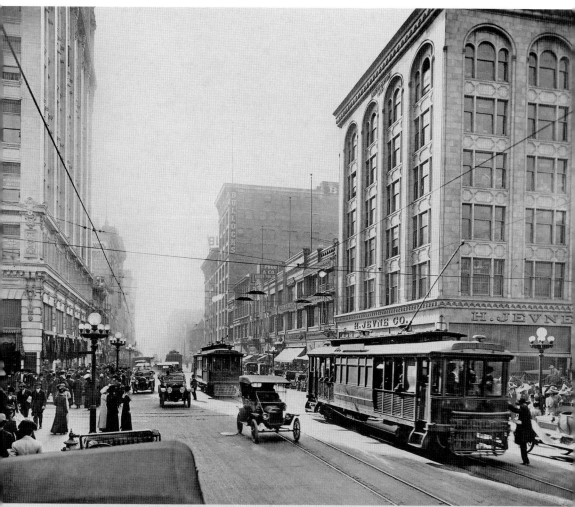

A Model T passes a Los Angeles Railway open-ended Type B trolley, specifically designed by Henry Huntington's engineers for use in Southern California's balmy weather. Through many mergers and buyouts, Huntington made many lines into one, as shown here on the southwest corner of Broadway and Sixth Street at Hans Jevne's Grocery Store around 1910. (Courtesy Western Railway Museum.)

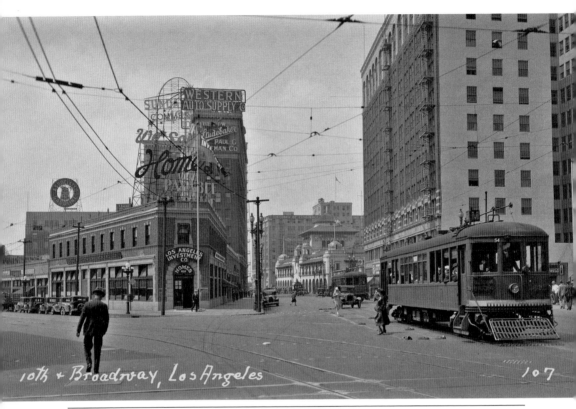

10th & Broadway, Los Angeles 107

LARY's 10-story building (left, center) opened in 1925 when this photo was taken, and in the 1960s Shirley Crise did data entry here for the LAMTA. Today, it is the Hoxton Hotel. This corner of Tenth Street (today Olympic Boulevard) and South Broadway was once where LARY's multibranched M-Line passed (1920–1932), replaced by Lines 7, 8, 9, and 10 and then abandoned. Metro Bus Line 30 heads to the Downtown L.A. Arts District Station. (Courtesy Golden West Books, Donald Duke Collection.)

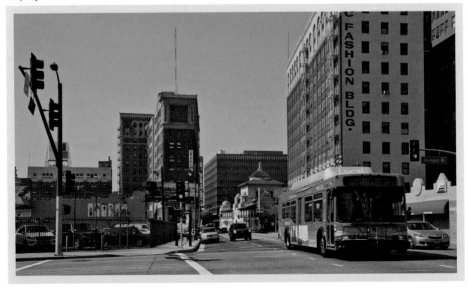

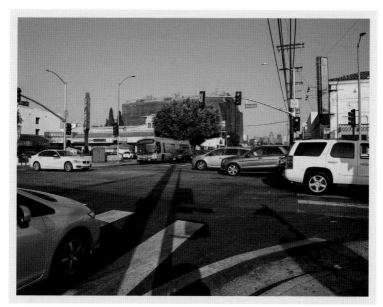

LARY's P-Line ran from East First Street to West Pico Boulevard and remained one of the most heavily traveled routes. In 1925, at Pico and Western Avenue in Harvard Heights, car 367 is westbound on Pico Boulevard to South Rimpau Boulevard.

Metro bus 8505 is heading west along Line 30 to West Hollywood. Today, one can access route information with a smart device, but back then, the Railway Information Bureau's 24-hour phone number was MAin-4174. (Courtesy SCWHR.)

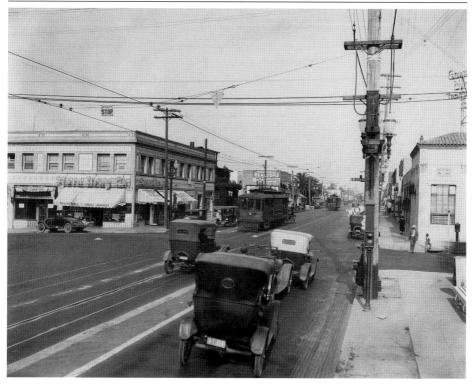

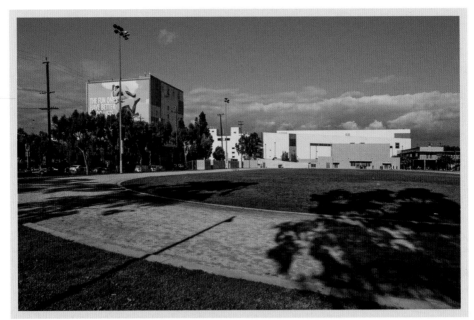

Southbound LARY car 1229 pauses on the M-Line, serving Hill Street and Grand Avenue (at Thirty-Seventh Street) along a private right-of-way, around 1930. The M-Line first appeared May 9, 1920, disappeared in 1932, and reappeared in 1939, only to be permanently abandoned in 1941. The Birch-Smith Fireproof Storage Building has survived and is still a storage facility today. The Jackie Robinson Charter High School track and field is shown in the modern image. (Courtesy Craig Rasmussen collection.)

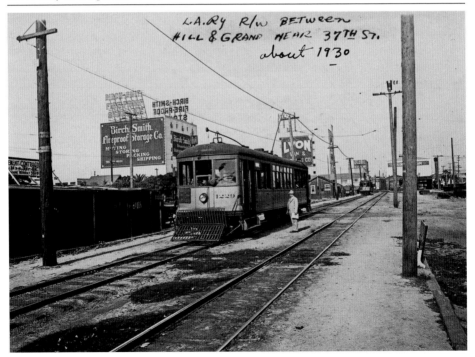

E PLURIBUS UNUM: HUNTINGTON BUILDS AN EMPIRE

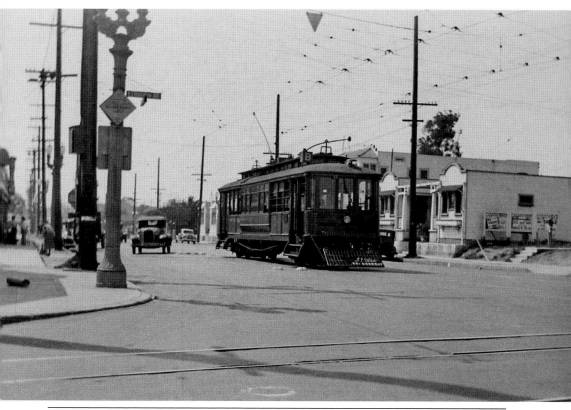

LARY car 1166 (formerly car 24) is shown heading east on the B-Line, which served Brooklyn Avenue (now Cesar Chavez Avenue) and Hooper Avenue. This Type-F car soon will merge onto Evergreen Avenue (E-Line) and head north, having passed Evergreen Cemetery. The Metro bus serving Line 770 also goes by the cemetery and will terminate at the El Monte Station. The apartment building to the right of both vehicles has continued to survive. (Photograph by Eugene Van Dusen, courtesy MLPSI, Malcolm McCarter Collection.)

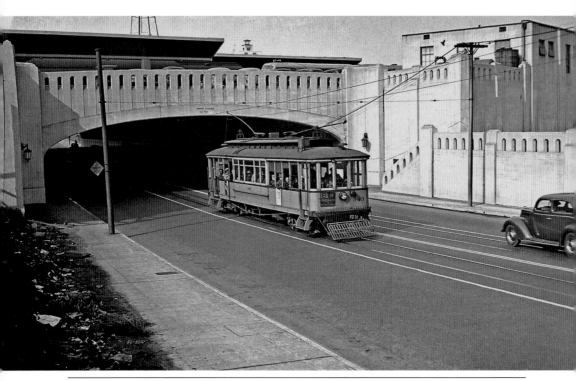

The dash sign on LARY 343 states it is heading to Brooklyn and Evergreen Avenues via the B-Line as it heads out from under the tracks at the Los Angeles Union Passenger Terminal on Macy Street (now Cesar Chavez Avenue). Trolleybuses would take over this line by 1948. The articulated Metro Rapid bus is coming to its final stop on Line 733 at the Patsaouras Transit Plaza on the east side of Union Station. (Courtesy Tom Gray.)

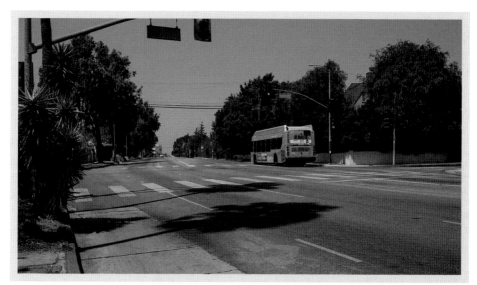

The L-Line served Los Angeles High School via Country Club Drive and is heading west as it merges onto Olympic Boulevard at Lucerne Boulevard. It will soon terminate at Los Angeles High School on the left and pass Fremont Place on the right in this c. 1939 photograph. The L-Line closed in May 1940. The house on the right remains, although obscured by foliage. Metro bus 4152 is heading west on Line 728. (Photograph by Ernie M. Leo, courtesy Craig Rasmussen collection.)

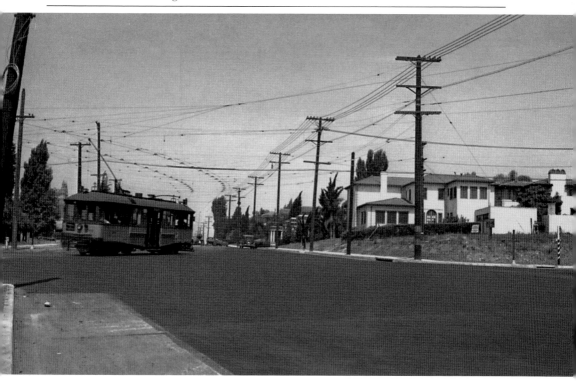

L-Line car 873 glides along Victoria Avenue at Country Club Drive around 1939. This Type-C car is heading outbound to Los Angeles High School and the Los Angeles Memorial Library. Victoria Avenue no longer has visible tracks, but otherwise, the neighborhood remains mostly unchanged. Some locals know the rails were never removed but simply paved over. In the background of the 2013 image, inbound Metro Bus Line 728 heads east on Olympic Boulevard. (Photograph by Wilbur C. Whittaker, courtesy Tom Gray.)

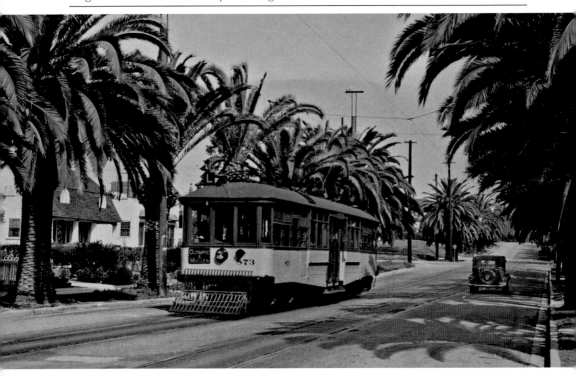

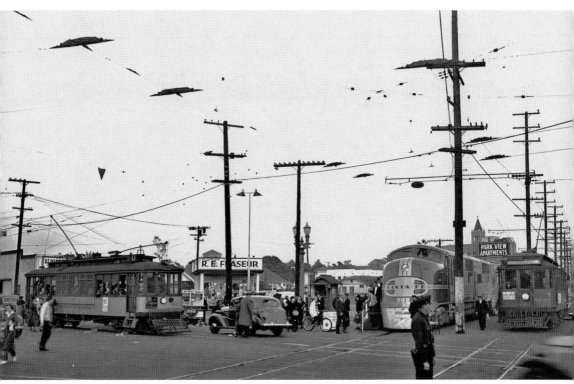

In 1939, the Santa Fe displayed their Super Chief passenger train on Exposition Boulevard. The LARY U-Line car 312 (on Vermont Avenue) pauses at left while PE 913 waits on the Santa Monica Airline at right. USC's Mudd Hall and Park View Apartments can be seen in the vintage photo, but campus expansion has removed the apartment building and corner gas station. Metro's Expo Line now serves this area along much of the same right-of-way. (Courtesy GWB, Donald Duke Collection.)

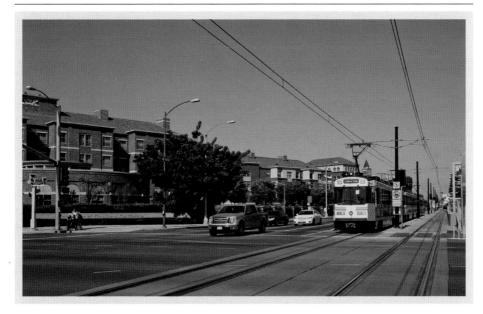

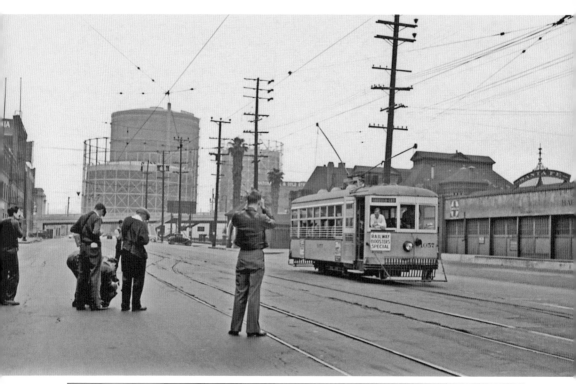

Birney 1057 stops at Santa Fe's Le Grande Station on Santa Fe Avenue at East Second Street on June 4, 1939. This Railroad Boosters special fan trip, dubbed "Nowhere in Particular," took railfans on the L-Line and east side shuttle trackage. Note the natural gas storage bladders in the background of the vintage photograph. In the modern image, a Metro light rail car can barely be seen crossing the bridge from East Los Angeles. (Photograph by Ralph Melching, courtesy Pacific Railroad Museum.)

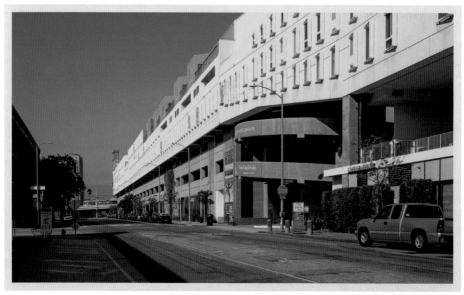

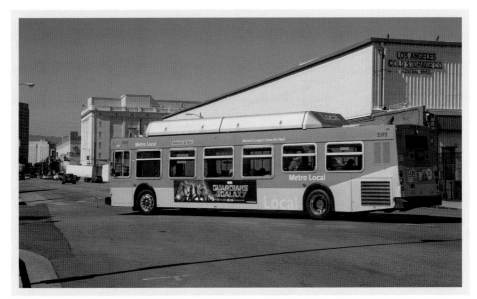

Before Los Angeles Union Station centralized mainline passenger traffic, each major railroad had its own station. Southern Pacific Railroad's Central Station (Central Avenue at Fifth Street) was once a grand edifice. Two LARY cars stop here in June 1939. Three-Line (Whittier Boulevard and West Third Street) PCC car 3008 (left) and D-Line (west Sixth and Central Station) trolley 353 pause for passengers. Metro Local bus 5393 begins turning west on Fifth Street. (Photograph by Ivan Baker, courtesy Craig Rasmussen collection.)

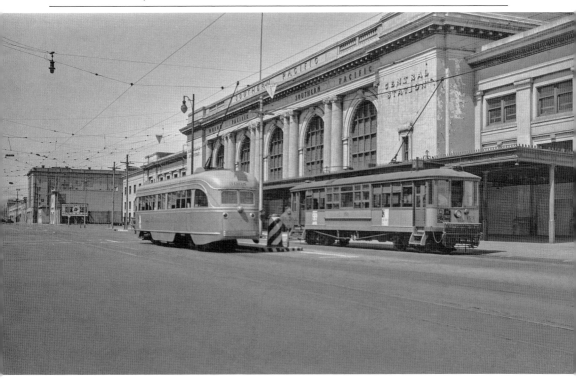

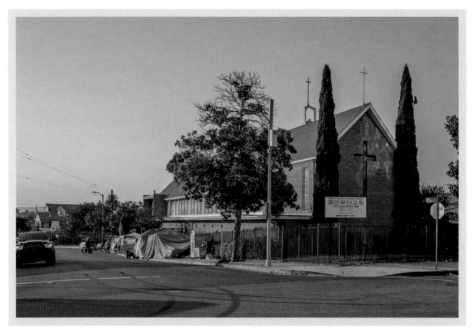

On its way to downtown Los Angeles, "sowbelly" L-Line car 882 is heading east on West Tenth Street at Gramercy Place around 1940, shortly before the line was abandoned. The eastern terminus at this time was Spring Street and Sunset Boulevard at the civic center. This was once an upscale neighborhood, and while the Trinity Lutheran Church took the place of a mansion, the homeless seeking refuge now live in tents nearby. (Photograph by Wilbur C. Whittaker, courtesy Tom Gray.)

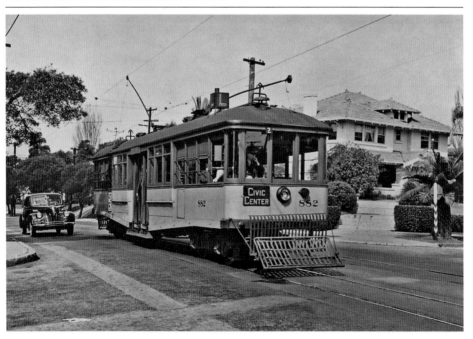

E PLURIBUS UNUM: HUNTINGTON BUILDS AN EMPIRE

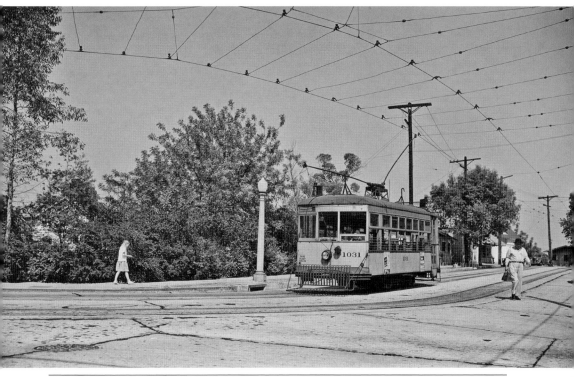

The Los Angeles Railway had several shuttle routes, and this was one of them. The Edgeware Road Shuttle Line operated from 1932 to 1939 and again from 1942 to 1946 before being replaced by a motor coach (bus). This c. 1940 image of car 1030 was taken on east Edgeware Road at Douglas Street, and there is no physical evidence today showing that this community was ever served by rail. (Photograph by Frank J. Peterson, courtesy GWB, Donald Duke Collection.)

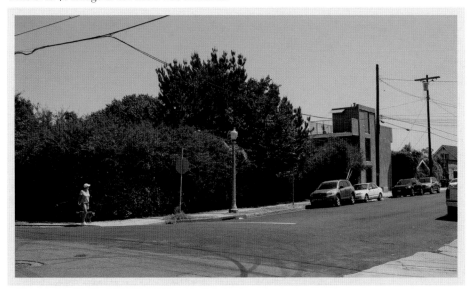

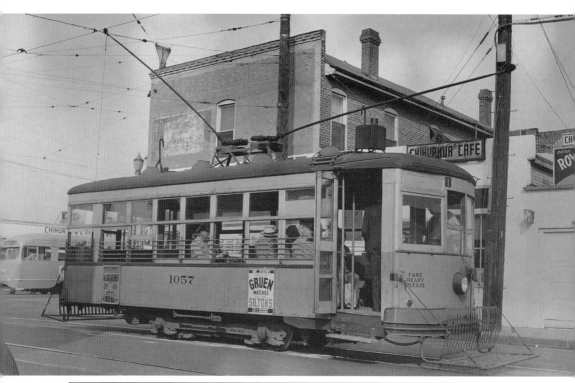

LARY Birney 1057 pauses on Indiana Street at First Street in East Los Angeles around 1940. This is the northern boundary of Wellington Heights, which is a traditionally Mexican enclave, as noted by the Chihuahua Café and Chihuahua Market. Even today, 93 percent of residents claim Mexican heritage. Today, Metro Rail 727 pauses at the Indiana Street Station before crossing First Street, where it appears some of the vintage architecture still exists. (Photograph by Wilbur C. Whittaker, courtesy Craig Rasmussen collection.)

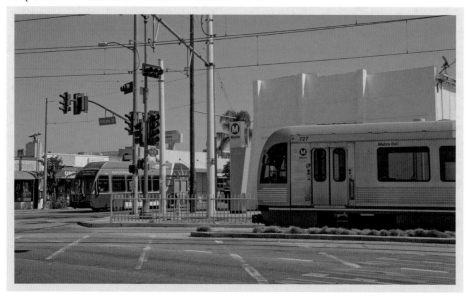

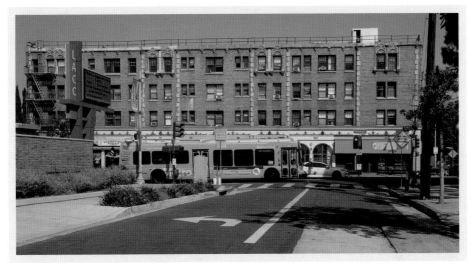

Laying over at Monroe Street and North Vermont Avenue, LARY car 915 waits to switch over and head back from the top of the V-Line to Vernon Avenue around 1940. The Marietta Hotel and Apartments building survives today. Metro bus 8619 heads southbound on Vermont Avenue at the eastern end of the Los Angeles City College (LACC) campus. Some historians may remember that this was the original campus of the University of California, Los Angeles (UCLA). (Photographer unknown, courtesy Western Railway Museum.)

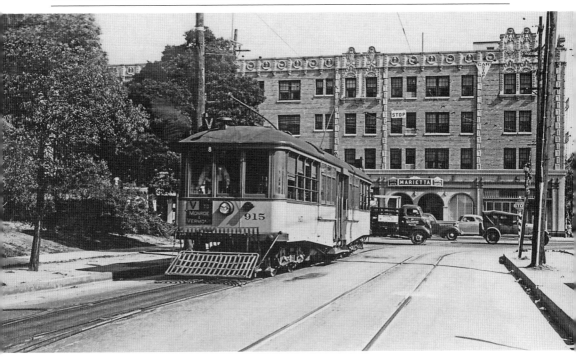

Only the former Safeway Market building survives on this stretch of Seventh Street at Lucas Avenue in the Westlake South neighborhood. In 1941, LARY car 1318 heads along the R-Line to its terminus at Third Street and La Brea Avenue. From 1947 to 1963, this served as a trolleybus line. Metro bus 3883 on Line 51 is heading to the Metro Wilshire-Vermont Station, where it also meets up with the Metro Rail subway lines. (Photographer unknown, courtesy Steve Crise collection.)

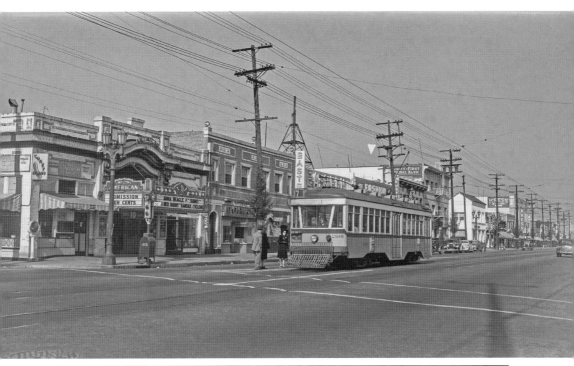

Experimental "Type M" car 2601 pauses by the American Theater (showing "Sunny" and "Kansas City Cyclone") on South Broadway at Forty-Seventh Street on July 12, 1941. This unique-looking car was one of two that had center doors and slanted windshield posts and frequented the 7-Line in the South Park neighborhood. The Kress building remains, but the theater is gone. Metro Bus 8011 traveling on Line 45 heads south to the Harbor Freeway Station. (Photographer unknown, courtesy John Bromley collection.)

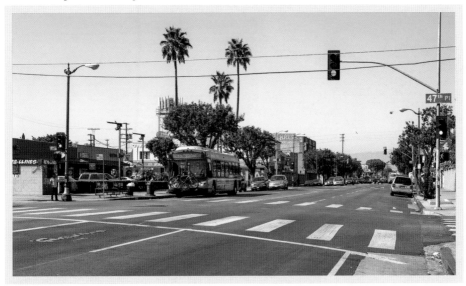

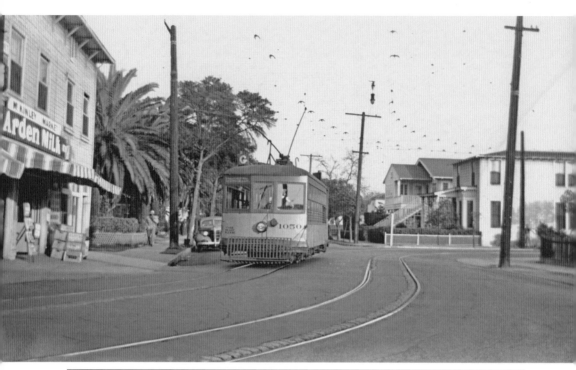

There is no current evidence suggesting there used to be either trolley service or a market at the corner of McKinley Avenue and Forty-Second Street. The G-Line (Griffith and Angelino Heights) Birney car 1050, shown here in December 1942, was from a different time indeed. This line was replaced by motorcoach service in 1946. Harmony Elementary School is on the right of the modern image, and this area no longer has bus service. (Photograph by Ivan Baker, courtesy Craig Rasmussen collection.)

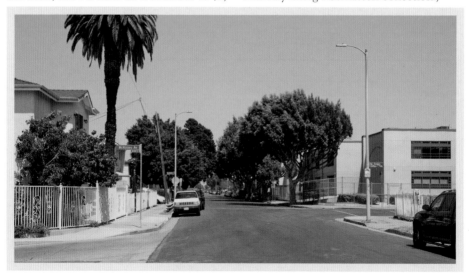

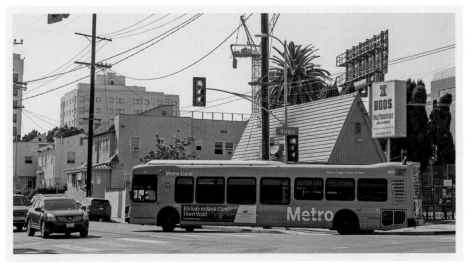

During World War II, ridership on the LARY continued to be popular, even though gasoline was only 17.5¢ a gallon at the Beacon gasoline station at the northwest corner of Fountain and Virgil Avenues. Car 39 was 28 years old when this photograph was taken on November 11, 1942, along the A-Line. In the modern image, Metro bus 8551 turns west on Fountain Avenue, and Hollywood Presbyterian Hospital is seen in the background. (Photographer unknown, courtesy Tom Gray.)

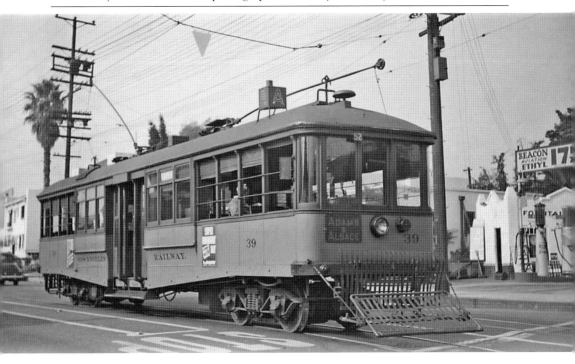

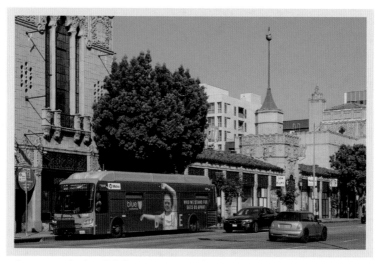

The special paint applied to PCC car 3010's roofline reading "Become a Trolley Pilot" exemplifies the wartime need for motormen on February 6, 1942. The 3-Line stopped in front of the Chapman Park Market near the Chapman Park Hotel and Bungalows, both named for Charles Clark Chapman, the owner/developer of this property from 1930 and namesake of Chapman University. This 1906 building remains in beautiful condition today, as Metro bus 5860 on Line 18 illustrates. (Photographer unknown, courtesy Steve Crise collection.)

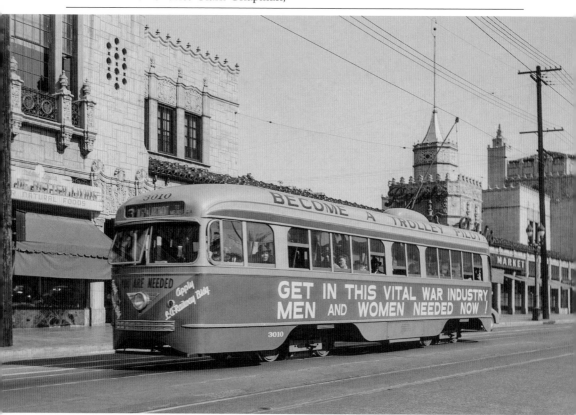

E Pluribus Unum: Huntington Builds an Empire

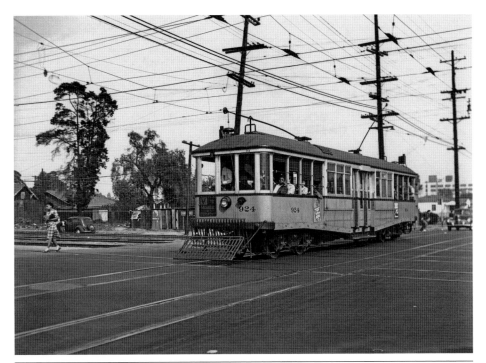

LARY car 924 heads west on the V-Line at Vernon Avenue, crossing the four tracks of the Pacific Electric Railway and Long Beach Avenue, October 14, 1944. The former PE right-of-way is still in use today by Metro Rail's A-Line. Metro Bus 7163, Line 105, is heading west over the A-Line tracks towards its destination in West Hollywood. The modern shopping center took over a former residential neighborhood. (Courtesy Craig Rasmussen collection, Harley L. Kelso photo.)

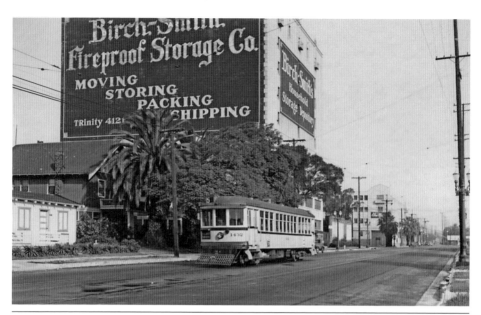

The Birch-Smith Fireproof Storage Company building unmistakably remains on South Grand Avenue just north of West Thirty-Fifth Street in this photograph from February 16, 1944. Car 1432 was an H-2 Type car dating back to 1923 and was designed to be operated in multiple unit (MU) configurations (two cars together). The dash sign shows Inglewood and Hawthorne as eventual destinations, and it was known as the Los Angeles Railway's interurban streetcar. (Photograph by Wildomar Seavers, courtesy Craig Rasmussen collection.)

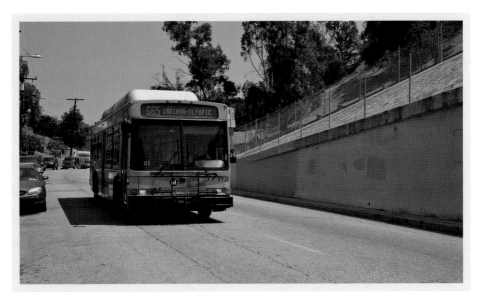

Birney Safety Car 1026 travels through City Terrace on the Gage Street Shuttle Line at Blanchard Street around 1945. The LARY had 70 such cars, featuring a single truck (wheel set), double motors, and motorman-only operation. This line became solely bus service on June 30, 1946. Today, the area is still serviced by Metro Bus Line 665, as bus 7738 travels south and will terminate at Indiana Street and Olympic Boulevard. (Photographer unknown, courtesy MLPSI, Michael Patris Collection.)

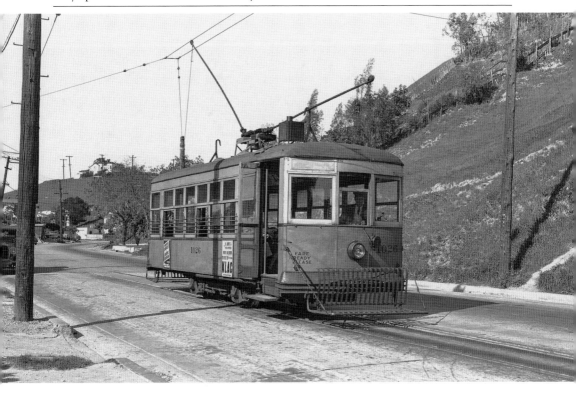

The Angelino Heights neighborhood of Los Angeles is one of the oldest in Southern California and features well-preserved Victorian architecture. Trolley service began here in 1886 and lasted 60 years before becoming a bus route. The early Edgeware Road Shuttle Line (originally Angelino Heights Line) photograph dates from March 22, 1943, with an unidentified motorman on what is now the 10-Line. The 1940s apartment building remains today, but there is no longer bus service. (Photograph by C.E. Wright, courtesy Craig Rasmussen collection.)

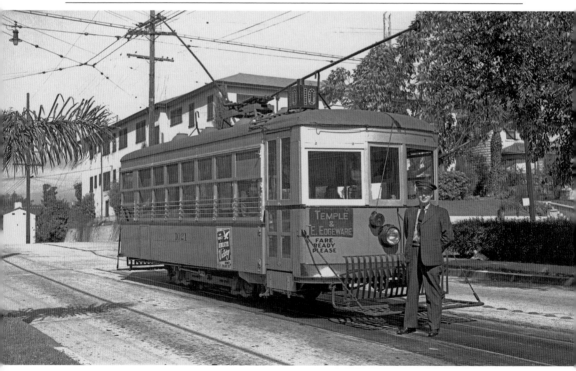

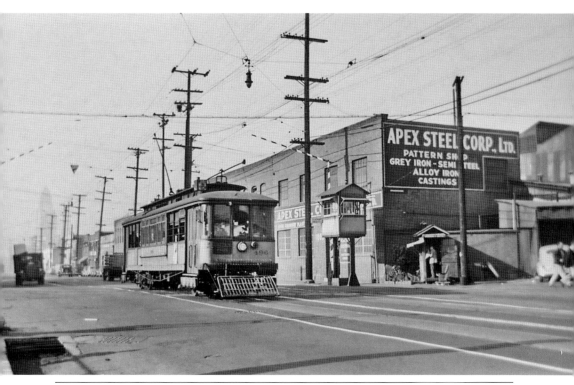

LARY car 496 heads northeast on the O-Line toward Lincoln Park in the 1100 block of North Main Street at the former Southern Pacific Railroad crossing in August of 1945. Note the flagman's tower near the corner of the Apex Steel building which helped control auto and rail traffic at the intersection. Los Angeles City Hall is in the background. Metro Bus 4064 on Line 76 is heading to the El Monte Station. (Photograph by Ivan Baker, courtesy Craig Rasmussen collection.)

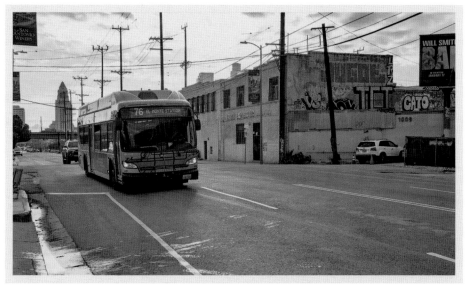

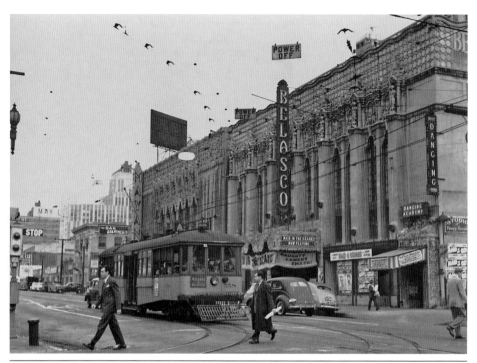

Architects Morgan, Walls, and Clements designed the still-surviving Belasco Theater and the adjoining Mayan Theater on South Hill Street at West Eleventh Street. These theaters date from the mid-1920s and are now historic cultural landmarks. LARY 558 prepares to turn west on the A-Line where Maid of the Ozarks is opening in 1946. Metro bus 3392 appears in the same spot on Route 794 as it makes its way to Hill Street and Venice Boulevard. (Photographer unknown, courtesy Western Railway Museum.)

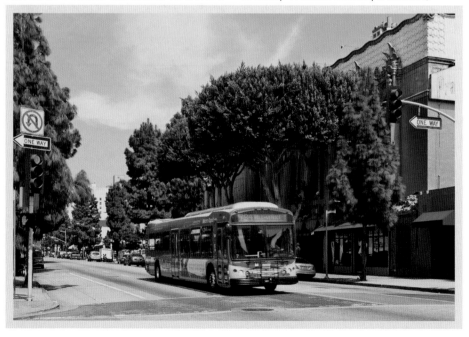

THE END BEGINS

LOS ANGELES TRANSIT LINES

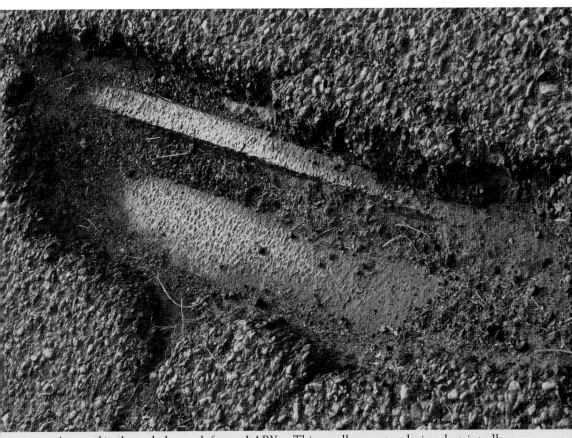

A wound in the asphalt reveals former LARY track buried on Selig Place at Lincoln Park where Lines 3, 8, L and O formerly operated. On January 10, 1945, Los Angeles Transit Lines was born, promising modernization. This usually meant replacing electric trolleys with diesel buses. Today, many tracks remain just below the pavement throughout LA. (2010 photograph by Steve Crise.)

The corner of Sixth Street and South Rampart Boulevard has not changed much since this photograph was taken around 1946 not too far from MacArthur Park. As LATL car 1398 turns east onto Sixth Street along the H-Line, the Rampart Market Building and apartments remain virtually unchanged. In modern times, Metro bus 3119 continues on Line 803, heading to the Metro Rail Civic Center Grand Park Station. (Photograph by Ray Younghans, courtesy SCRM.)

Looking northwest on San Fernando Road, the Union Pacific tracks to Pasadena (running left to right at Humboldt Street) are protected by wig-wag signals. LATL 1378 is heading southeast on the W-Line near the Los Angeles City Jail. In the background, Santa Fe Railway's historic Second District Bridge formerly supported famous passenger trains like the Super Chief and El Capitan along their Transcontinental Route. It has been repurposed for modern Metro Rail Gold Line traffic. (Photographer unknown, courtesy Steve Crise collection.)

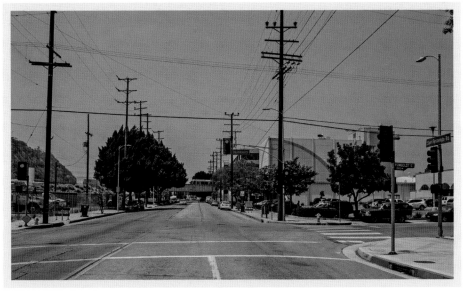

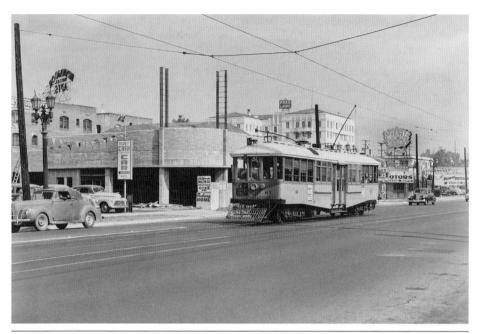

The structural horizon behind V-Line car 61 traveling along south Vermont Avenue at Fifth Street around 1946 shows the Brynmoor Apartments and Park Lane apartment buildings on New Hampshire Avenue that have survived all these years in the area known as Wilshire Center. The California Willys Car Company and vehicles no longer exist. Articulated Metro bus 9504 heads south on Line 204, much like its mass transit predecessors did decades ago. (Photograph by W.E. Johns, courtesy MLPSI, Malcolm McCarter Collection.)

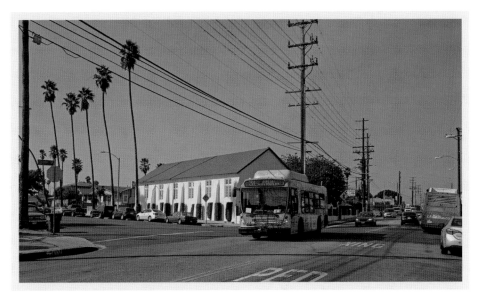

LATL Special Car 1212 passes Birney 1054 on South Indiana Street and East Fifth Street in the Wellington Heights area of East Los Angeles on February 16, 1947. The historic church in the background is now La Iglesia Christiana Fundamental La Trinidad. Metro bus 3144 travels Line 254 towards 103rd Street and the Watts Towers Station. Few passengers today realize they are traveling the same route previously frequented by trolley cars. (Photographer unknown, courtesy Michael Patris Collection.)

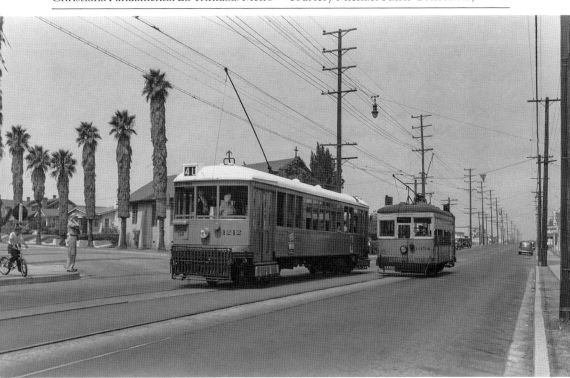

Overhead trolley wires in this c. 1948 photograph tell of electric trolley/bus service coming to this area on the B-Line at Evergreen Avenue and Cincinnati Street; LATL car 499 served its last days on this route. Continued development over the years leaves no clues to modern-day researchers and historians save the gentle rolling hills, as the topography remains similar. This northbound car has switched ends and will head south to Fifty-First Street and Ascot Avenue. (Photograph by Tom Gray, courtesy Steve Crise.)

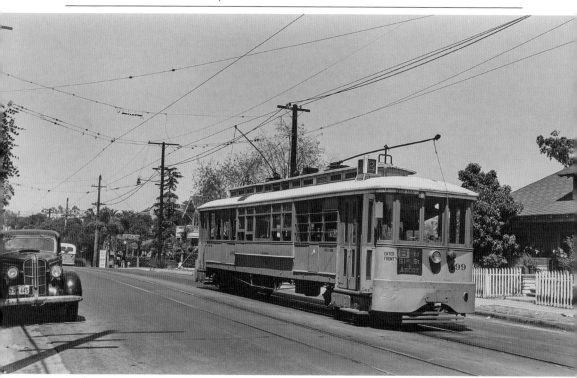

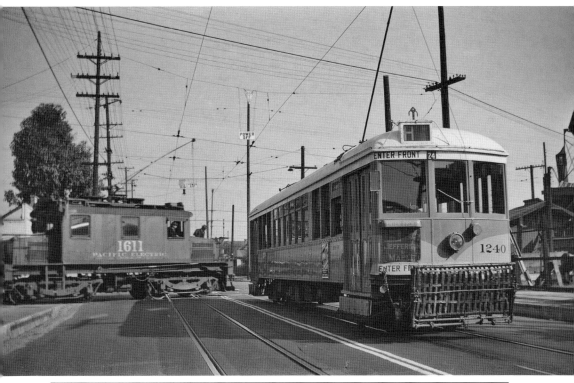

The tracks of the standard-gauge Pacific Electric Railway, narrow-gauge Los Angeles Railway, and successor companies crossed paths many times. Here, PE's 64-ton electric freight locomotive 1611 passes in front of LATL H-Line car 1240 for delivery on a private spur around 1947. The PE spur behind 3201 Maple Avenue at Thirty-Second Street in the historic South Central neighborhood is gone. Metro bus 5027 passes the same intersection along Route 48. (Photograph by Ray Younghans, courtesy Michael Patris Collection.)

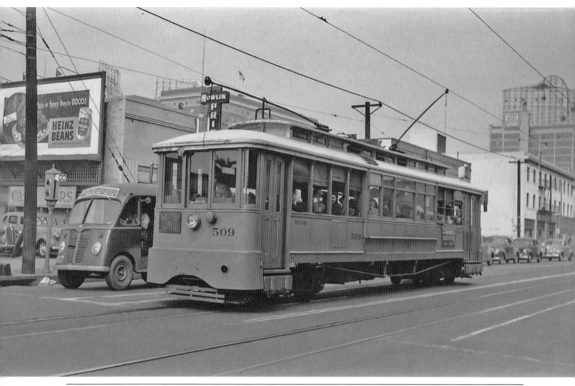

The masonry building in the Bruning Tract of South Main Street at Pico Boulevard has survived for more than a century, dating back to 1906. This photograph, taken in January 1948, shows Los Angeles Transit 8-Line car 509 heading south to Fifty-Fourth Street and Crenshaw Boulevard. While multiple Metro buses stop here today, shown is the City of Gardena's Green Bus 733 as it heads toward Redondo Beach. (Courtesy Steve Crise collection, formerly Tom Gray collection.)

THE END BEGINS: LOS ANGELES TRANSIT LINES

Car 1164 plies the 5-Line on the North Broadway Viaduct over the Los Angeles River at Pasadena Avenue. The bridge's original twin Roman columns from the 1911 opening are absent. A seismic retrofit and bridge restoration was completed under Los Angeles mayor Richard Riordan in 2000, and the rededication plaque now calls this the Buena Vista Bridge. Metro Bus 8507's destination sign reads "Face Covering Required" during the COVID-19 pandemic. (Photograph by W.E. Johns, courtesy MLPSI, Malcolm McCarter Collection.)

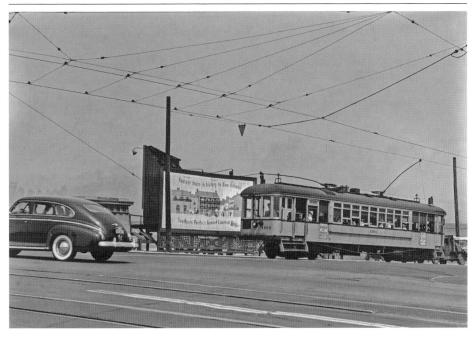

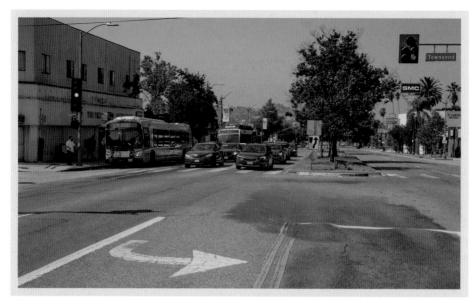

The northern terminus of the 5-Line in Eagle Rock at Colorado Boulevard and Townsend Avenue still shows a few clues since this 1948 photograph was taken. The former track bed is now a greenbelt, and Tritch Hardware is still around after opening in 1945, albeit in the one-story building next to where it lives today. The building dates from 1916 and is part of the Eagle Rock Townsite Tract. (Photographer unknown, courtesy Michael Patris Collection.)

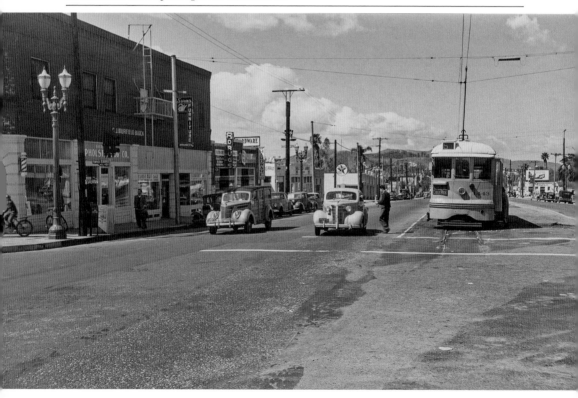

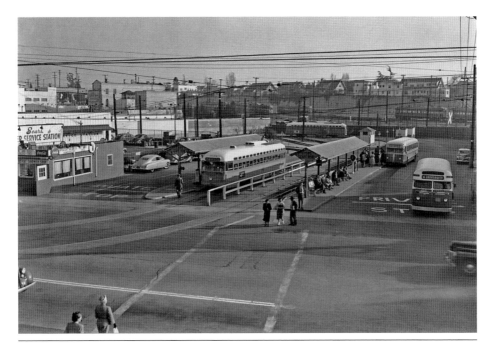

At the intersection of West Pico Boulevard and South Rimpau Boulevard, the Sears building and the P-Line loop in the vintage photograph were demolished to build the Midtown Crossing Shopping Center. Just behind lies PE's Vineyard Junction, where a Red Car consist is stored on the Venice Short Line in 1948. In the foreground are LATL PCC cars at left and PE buses at right. Metro and Santa Monica buses still run here. (Photographer unknown, courtesy MLPSI, Ross Fry Collection.)

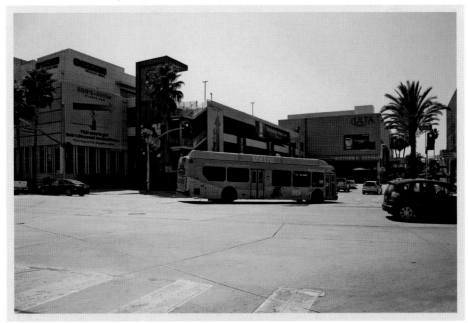

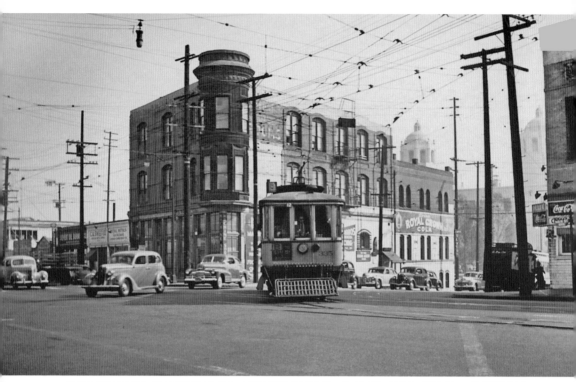

The current north end of historic Olvera Street at the corner of Main Street and West Cesar Chavez Avenue was always a busy intersection, as this January 1948 photograph indicates with LATL B-Line car 355. The block behind shows the US Post Office/Los Angeles Terminal Annex building, which is next to Los Angeles Union Station. Modern-day bus traffic is continuous, as LAMTA now owns Union Station. (Photograph by Alan Weeks, courtesy of the photographer.)

Virtually nothing remains the same from this c. 1948 photograph taken at Vermont Avenue and West Fifty-Fourth Street. Vermont Avenue Presbyterian Church is gone, and a newer shopping center is at the corner. LATL 1447 heads south and passes 1439 on the F-Line. The same frequency exists today, with Metro articulated bus 9521 heading to the Vermont/Athens Station along Route 754. Today, this line has 24 stops to complete in 66 minutes. (Photographer unknown, courtesy Michael Patris Collection.)

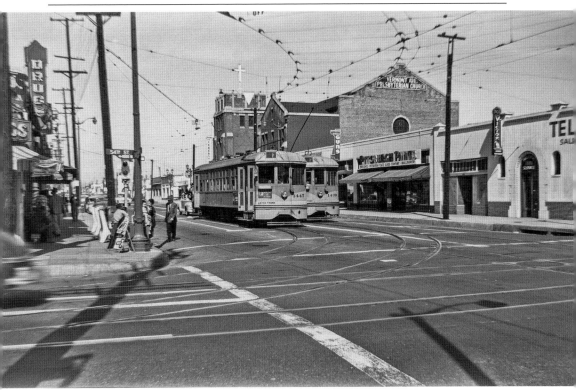

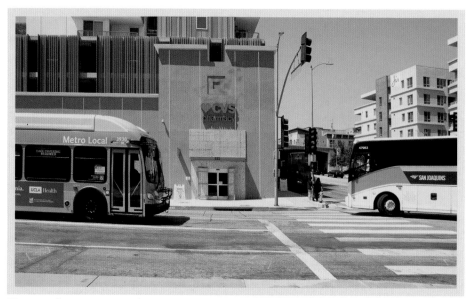

Time and construction have completely changed the southwest corner of North Broadway at Sunset Boulevard (now Cesar Chavez Avenue), just a few blocks east of where Sunset Boulevard now begins. LATL 199 pauses on the 9-Line before returning south. This streetcar was built by the American Car Company of St. Louis in 1898 for the Los Angeles Traction Company as car 122, and then renumbered to car 797 for the PE after the "Great Merger of 1911." (Photographer unknown, courtesy Michael Patris Collection.)

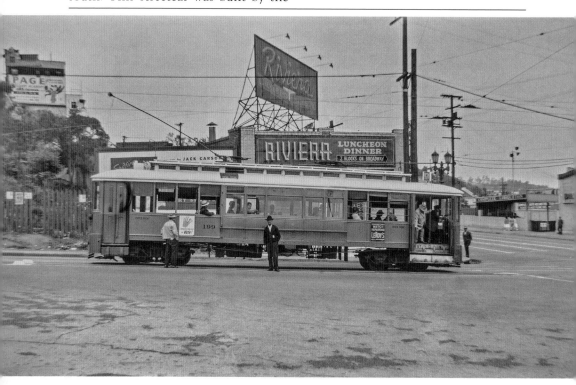

THE END BEGINS: LOS ANGELES TRANSIT LINES

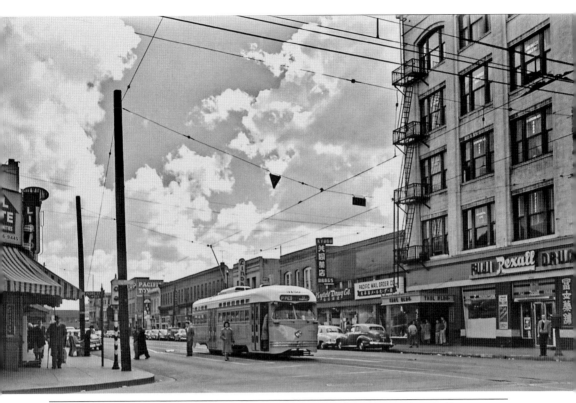

East First Street at San Pedro Street has been known as "Little Tokyo" for generations and continues its proud heritage today. LATL PCC car 3150 stops in the center of the street for P-Line passengers in this postwar photograph. Some of the buildings remain original to the area. Los Angeles Department of Transportation (LADOT) DASH Bus 15301 turns off First Street along the A-Line, where it connects to other Metro stations within the city. (Photographer unknown, courtesy Steve Crise collection.)

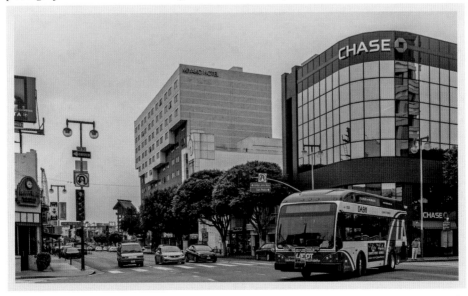

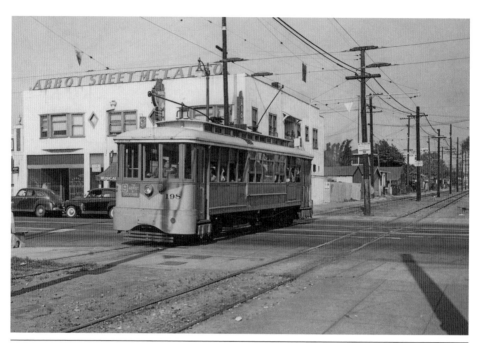

The mixed-use Abbot Sheet Metal building still exists alongside the former Los Angeles Transit Lines private right-of-way, just west of Forty-Eighth Street on South Vermont Avenue and just south of USC. LATL car 198 travels the 9-Line onward to Forty-Eighth Street and Crenshaw Boulevard, just south of Leimert Park, where LAMTA has built a light rail station, which will further connect to Los Angeles International Airport. (Photograph by Andy Payne, courtesy Craig Rasmussen collection.)

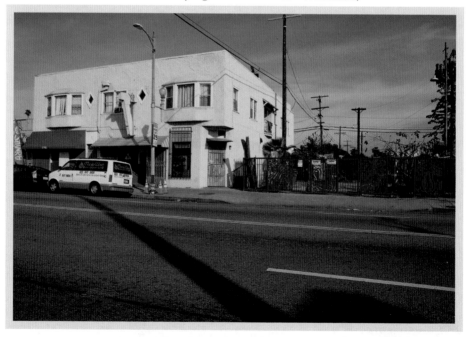

THE END BEGINS: LOS ANGELES TRANSIT LINES

Looking south on Main Street past the plaza at Olvera Street, the historic Pico House Hotel retains its grandeur as part of the city's beginnings. On the right, Our Lady Queen of Angels Roman Catholic Church also survives, but the former right-of-way has become a parking lot. LATL 1208 on the F-Line pauses around 1950 while articulated Metro bus 9532 passes the same way along Route 733. "Face Covering Required" in this COVID-19-era photograph. (Photographer unknown, courtesy Michael Patris Collection.)

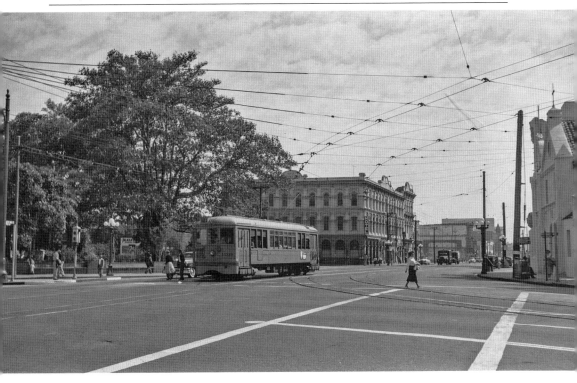

West Pico Boulevard at Windsor Boulevard looks like it did when PCC car 3142 headed east on the P-Line around 1950. Coauthor Steve Crise grew up on Lucerne Boulevard and used to catch the P-Line car at the Plymouth Boulevard stop. The Crise family took this car downtown for their shopping. Steve's mom worked for the LAMTA, and he was provided with a free system pass. Santa Monica's Big Blue Bus shares this corridor with Metro. (Courtesy MLPSI, Ross Fry Collection.)

THE END BEGINS: LOS ANGELES TRANSIT LINES

The Elysian Valley area of Los Angeles is bordered by the Los Angeles River to the southwest as well as the former Taylor Yard freight facility for the Southern Pacific Railroad (now Metrolink Central Maintenance Facility). Looking east on Cypress Avenue at Macon Street, LATL 5-Line car 1282 heads along double track, which still serves the community as a bus corridor. The new construction c. 1950 has been demolished and rezoned. (Photograph by Donald Strickland, courtesy Pacific Railroad Museum.)

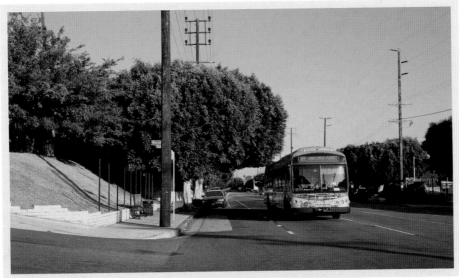

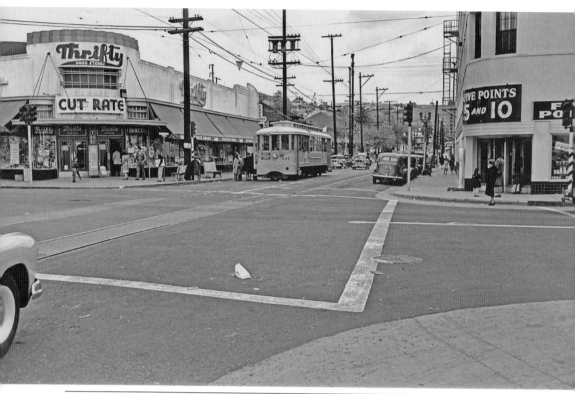

Five Points, or Cinco Puntos, is a well-known area of Lincoln Heights. Pasadena Avenue, West Avenue 26, East Avenue 26, and Daly Streets all converge here, and it's where locals did their major shopping as well as using it as a meeting place for family and friends. This c. 1950 photograph shows LATL 9-Line car 447 stopping at Thrifty's Drug Store, which remains today as Rite-Aid. Its award-winning ice cream is made in nearby Rosemead. (Photographer unknown, courtesy Michael Patris Collection.)

Built in 1931 as a clothing store, the Selig Commercial Building, on the northwest corner of South Western Avenue and West Third Street, is easily an art deco masterpiece, displaying black and gold tiles and ornamentation. In recent years, it has been a bank, and it now has several small storefronts, becoming a historic landmark in 1985. The St. Charles Apartments also survive where LATL S-Line car 1376 is southbound around 1950. (Photograph attributed to Joe Moir, courtesy Michael Patris Collection.)

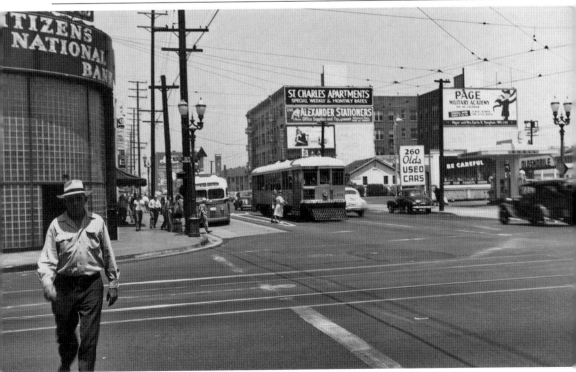

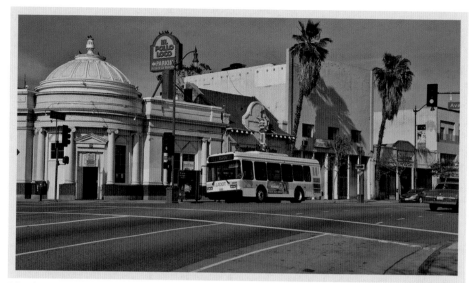

The former California Bank Lincoln Heights Branch, at 2201 North Broadway and Avenue 22, was vacant back in the mid-1950s, when this photograph was taken. Now it is a cultural landmark and one of the fanciest El Pollo Loco franchises ever seen! LATL W-Line car 1443 is shown heading towards downtown as does the modern-day LADOT DASH bus 03008, passing numerous surviving vintage buildings of notable architecture. (Photographer unknown, courtesy Western Railway Museum.)

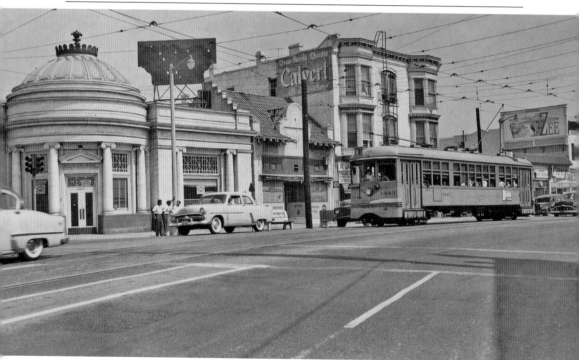

THE END BEGINS: LOS ANGELES TRANSIT LINES

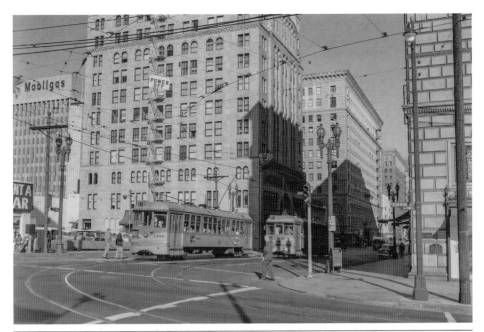

While the roads themselves have not changed at Seventh and South Figueroa Streets, the Financial District has transformed completely into a modern metropolis. Gone are Mobilgas's General Petroleum offices and animated red neon rooftop Pegasus, as well as the low-rise buildings of earlier vintage. Metro bus 6096 travels Route 51 today along with numerous other buses, just like the LATL S-Line cars 1426 and 1424 heading west to turn south on May 28, 1953. (Photograph by Harold F. Stewart, courtesy Steve Crise collection.)

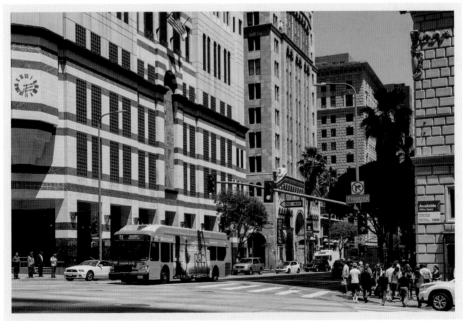

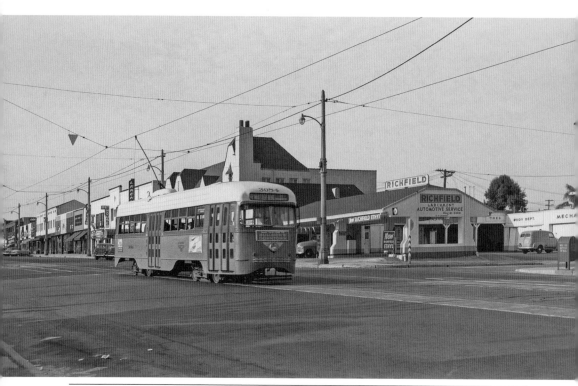

Larchmont Village is a half-mile square but well sought-after since the 1920s, being a "streetcar community" with walkable shops and restaurants. The Richfield gas station made way for Bank of America, and the PCC car made way for numerous upscale automobiles. This Larchmont Boulevard 3-Line LATL streetcar pictured on July 16, 1954, is headed south at First Street at Larchmont Boulevard. (Photograph by Harold F. Stewart, courtesy Steve Crise collection.)

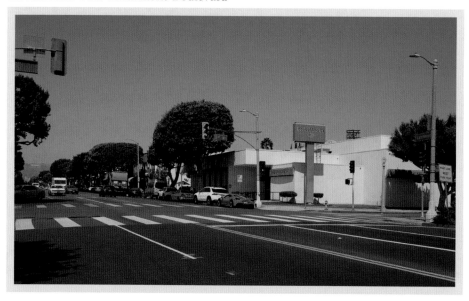

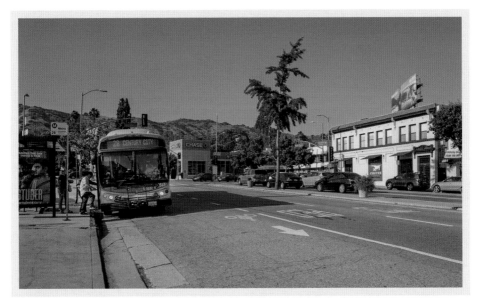

Colorado Boulevard at Townsend Avenue was the former end of the LARY and was once thought to be the center of Eagle Rock. With the advent of the automobile, commercial developers Edwards and Wildey erected the brick building on the south side of Colorado Boulevard at Eagle Rock Boulevard in 1916 and later the bank building on the north, thus changing the terminus. LATL 5-Line car 1426 and bus 6185 pause for passengers on June 6, 1954. (Photograph by L.L. Bonney, courtesy Michael Patris Collection.)

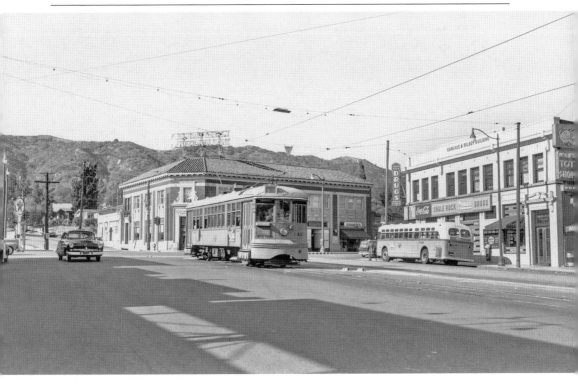

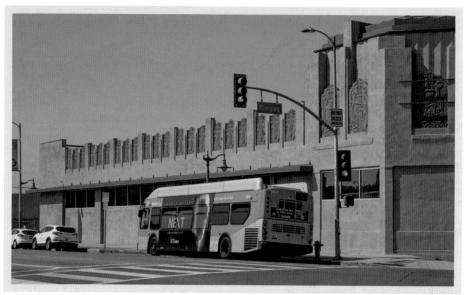

The art deco building at 4813 West Washington Boulevard at South Rimpau Boulevard was built in 1930 and was, for many years, a Bank of America branch. The building has survived along this still-active commuter corridor where LATL 1515 was heading to Avenue 50 and York Boulevard along the W-Line around 1956. Metro bus 5839 travels the same path today, servicing many routes in hopes these iconic art deco buildings remain intact. (Photographer unknown, courtesy Michael Patris Collection.)

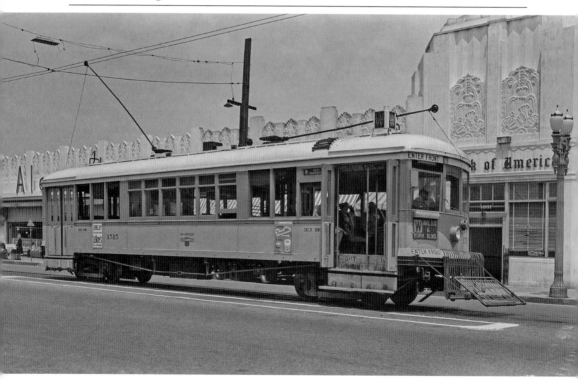

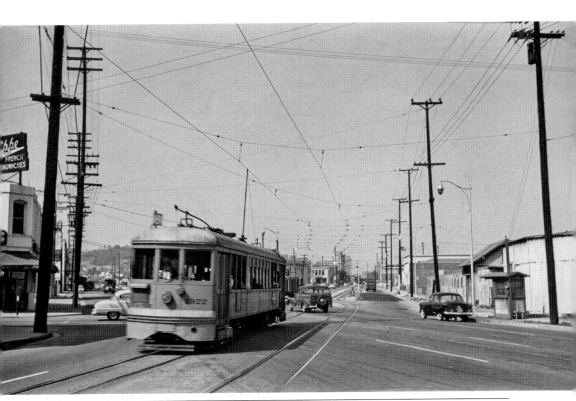

LATL 1322 travels inbound along the 8-Line on May 15, 1955. Surely even then kids yelled "STOP!" at North Main Street at Alameda Street to dine at the famous (and delicious) Philippe French Dipped Sandwiches and have Balian Ice Cream for dessert. Thankfully, the Binder family still runs the famous restaurant, and the authors wish them many more years of success. Metro bus 3104 travels the 603 Route, as does LADOT DASH and others. (Photographer unknown, courtesy Michael Patris Collection.)

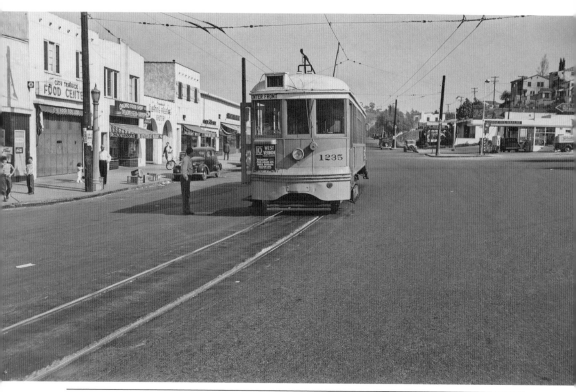

LATL 1235 stops along the 10-Line at City Terrace Drive and Miller Avenue around 1955. The dash sign lists the stops as West Vernon Avenue, Pico/Grand Avenue, Santa Barbara Street, and Dalton Avenue, which is unusual. The 76 station on the right has been replaced by a car wash, but the vintage commercial buildings have survived. Metro bus 5927 travels the area now along Route 70. (Photographer unknown, courtesy Michael Patris Collection.)

Something's special about night photography, especially when few but experienced shutterbugs created amazing images. Such is the case here, where LATL 1387 pauses on the R-Line before heading towards Whittier Boulevard around 1955. This iconic building has been an upscale furniture store, Samy's Camera, and now Trader Joe's, but the amazing weathervane with a woolly mammoth and a saber-toothed cat hearken to the tar pit heritage at West Third Street and La Brea Avenue. (Photograph by Robert McVay, courtesy peryhs.org, Ralph Cantos Collection.)

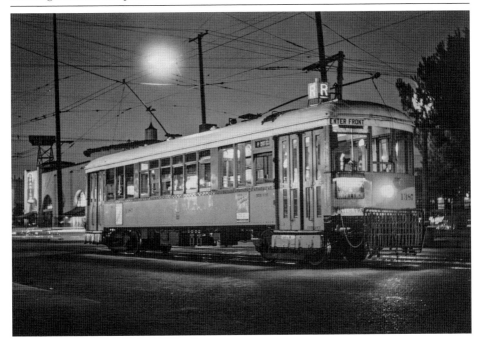

Infrastructure surrounding Vernon Avenue at Long Beach Boulevard has changed little since this c. 1955 photograph was taken. Crossing the PE's Los Angeles–Long Beach Line, LATL tower car 9350 heads east on the V-Line. The PE ceased passenger operations in 1961, but Metro revamped the right-of-way, opening the Blue Line in 1990 (now the A-Line). Car 9350 survives today at the Southern California Railroad Museum in Perris; Metro Bus Route 105 now serves passengers' needs. (Photograph by Bill Whyte, courtesy Steve Crise collection.)

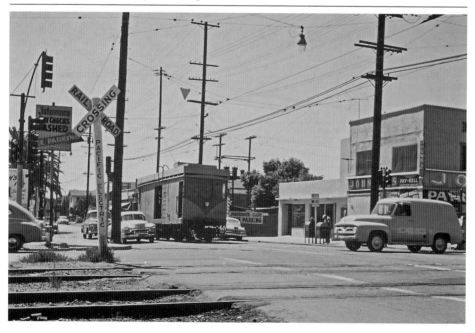

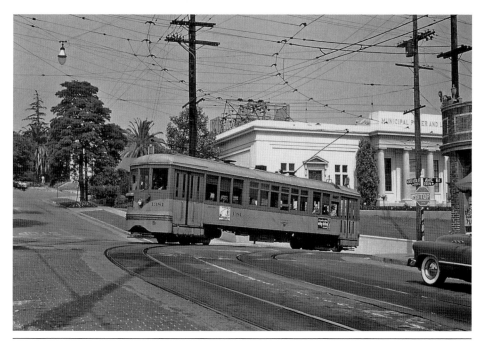

In the Highland Park area of Los Angeles, LATL car 1381 turns south from Avenue 61 onto Monte Vista Street along the W-Line on May 21, 1955, in a photograph taken by 23-year-old Alan Weeks. The historic Los Angeles Bureau of Power and Light building is in the background. Metro Bus 5965 turns south on Route 83, traveling along much of the same historic route on which LATL terminated service November 18, 1956. (Courtesy Alan Weeks.)

Most of the great neon signs along West Pico Boulevard at Mullen Avenue are gone, but the Sinclair Paint store has become Vista Paint since this photograph was taken on March 1, 1955. LATL PCC car 3129 heads east on the P-Line, as does the modern Metro bus 8588 along what is now Route 30 near the Midtown Crossing Shopping Center. (Photographer unknown, courtesy Steve Crise collection.)

The iconic Chinatown area along North Broadway at West College Street was relocated here when nearby Los Angeles Union Station was being built in the 1930s. This photograph, taken in November 1956, shows the great architectural details that have survived decades. LATL car 1440 is southbound on the W-Line, and the modern photograph shows Metro bus 8526 on Route 45 and LADOT DASH bus 13308 heading to the Financial District. (Photograph by Bruce Ward, courtesy MLPSI, donated by Jim Kreider.)

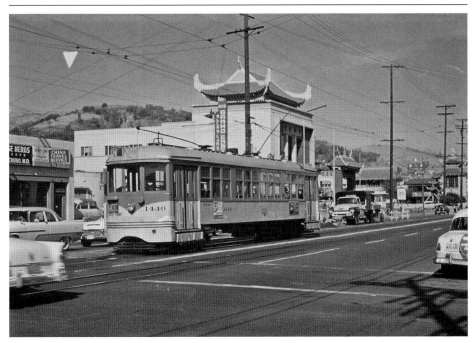

Downtown L.A.'s low-rise skyline was unchanged for decades, as this photo from May 14, 1958, attests. The Harbor Freeway below was then known as State Route 11 and now is State Route 110. Skyscrapers have replaced the Wellington Apartments and surrounding area, but the Seventh Street Bridge still serves mass transit passengers as it did when LATL PCC car 3062 traveled along the R-Line. Metro Bus 4028 now travels on Route 51. (Photograph by Harold Stewart, courtesy Steve Crise.)

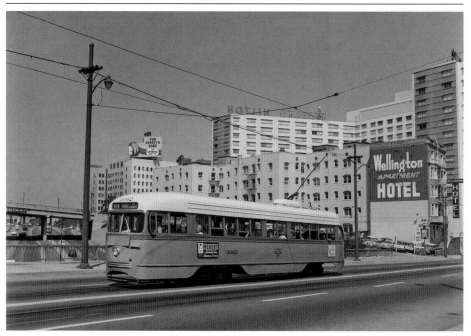

WHEN STREETCARS
WERE MADE TO CRY

THE LAMTA YEARS

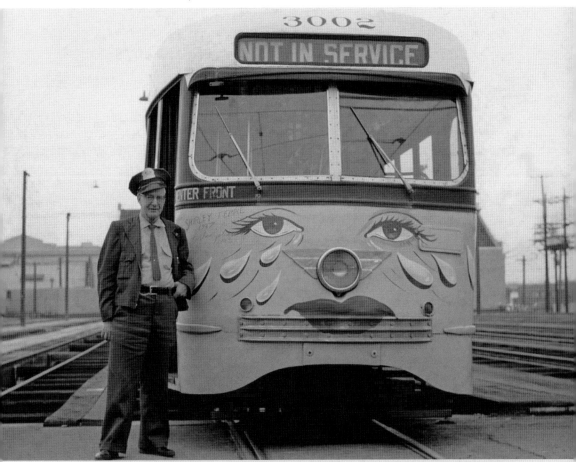

Motorman Easton Tindall stands alone at the Georgia Street car house beside PCC car 3002, the last car to run on the P-Line following regular service on March 31, 1963. This is quite the contrast from when actress Shirley Temple and 10,000 spectators inaugurated this car in 1937. Graffiti near the motorman reads "Shirley Temple 1937" (Photograph by Bill Whyte, courtesy Steve Crise collection.)

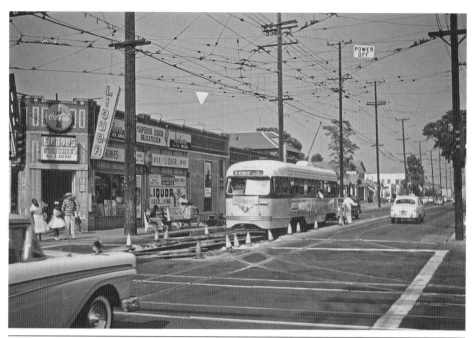

The construction on the V-Line in front of Superior Liquor and Delicatessen around 1960 didn't hamper pedestrians or trolley traffic as LAMTA car 3103 nears the intersection of West Vernon and South Vermont Avenues in the Vermont Harbor District. Until the final days, the LAMTA diligently maintained the infrastructure and made improvements. Today, Metro Local Routes 705 and 105 continue the mass transit tradition in this neighborhood, as does the LADOT DASH bus. (Courtesy peryhs.org, Jack Finn Collection.)

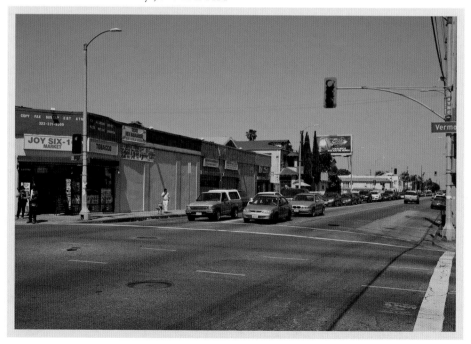

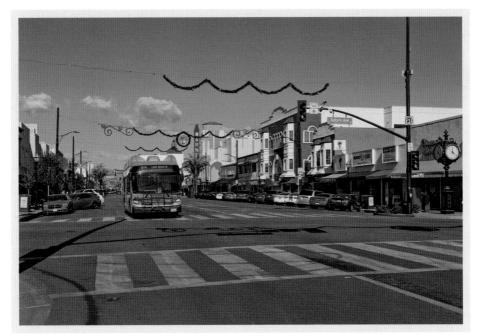

Huntington Park's Pacific Boulevard at Saturn Avenue has been a shopper's mecca for decades, as seen on November 18, 1962. LAMTA's Special PCC car 3001 on the J-Line pauses for Christmas shoppers. Warner's 1930 art deco theater still survives; architect B. Marcus Priteca designed this 1,468-seat showplace and the Pantages Theater in Hollywood as well. Further down the street, the Eastern Columbia Outfitting Company building also survives, albeit without its decorative spire. (Photograph by Roger Fogt, courtesy Pacific Railroad Museum.)

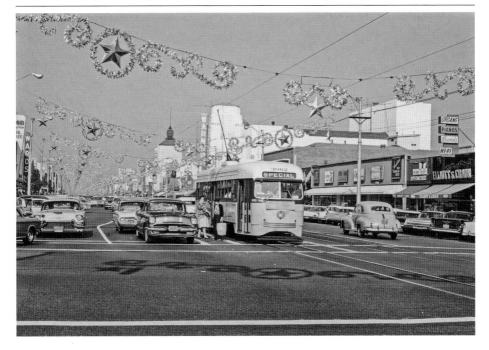

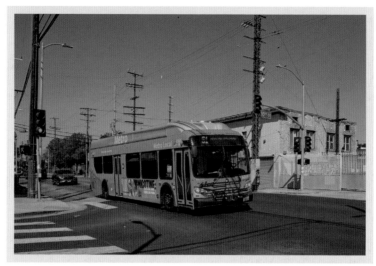

LAMTA's Special PCC car 3156 is heading south on San Pedro Street at East Thirtieth Street in the historic South Central neighborhood of Los Angeles. The mixed-use building and unique power pole in the background survive, as do many other small commercial buildings and homes in the area. Metro Local bus 6069 is following a similar course on Route 51 toward the Avalon Station then on to Compton. (Photograph by Richard R. Donat, courtesy Pacific Railroad Museum.)

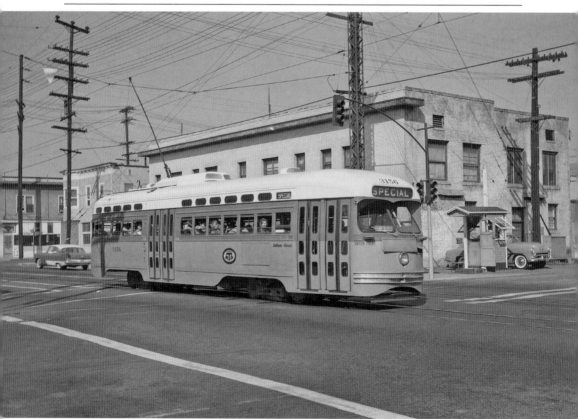

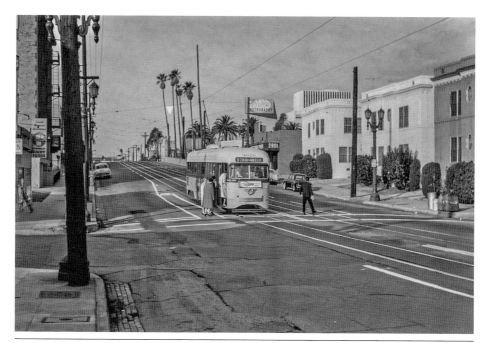

The MacArthur Park area, west of Downtown LA, has seen a lot of changes since LAMTA PCC car 3020 ran on the S-Line on January 12, 1963, just a few months before all streetcars were replaced by buses. The development continues along West Seventh Street at Magnolia Avenue, and many of the small businesses, like Alfred & Fabris Photography, which specialized in school photographs and yearbooks, are gone. (Photographer unknown, courtesy Steve Crise collection.)

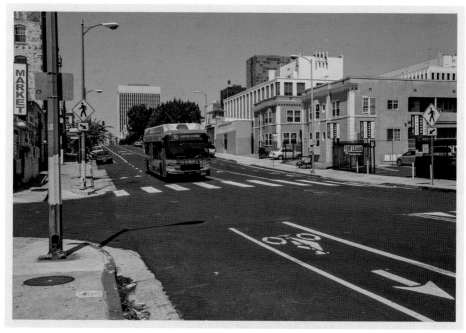

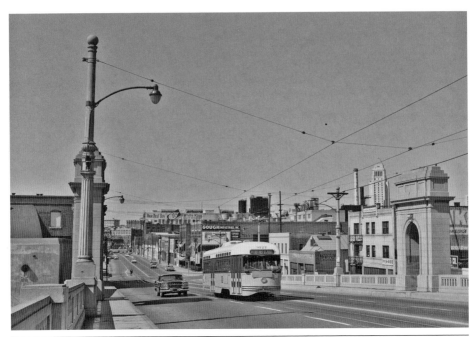

The last LAMTA cars ran the P-Line in 1963, like PCC 3127 over the First Street Bridge. Metro's L (Gold) Line extension to East Los Angeles 48 years later shows how downtown has grown. The First Street Viaduct is the second oldest of the iconic Los Angeles River bridges, designed by city engineer Merrill Butler. Metro made accurate replicas of the original light fixtures and other design elements capping off this enormous undertaking. (Photograph by Donald Duke, courtesy GWB.)

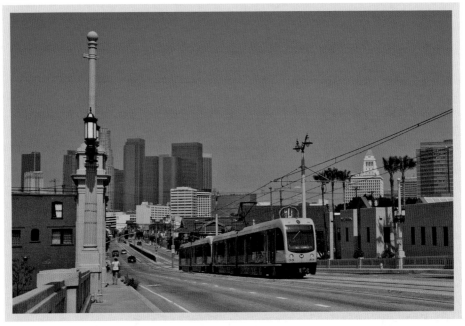

When Streetcars Were Made to Cry: The LAMTA Years

On the R-Line, LAMTA's PCC 3089 approaches the Gramercy Place private right-of-way at west Third Street and South Wilton Place on a rainy February morning in 1963. Photographer Donald Duke's 1959 Dodge station wagon is parked along the right side of the street, so as to not interfere with the composition of his image. In modern times, Metro Bus 5472 travels along on Route 16, duplicating part of this original path. (Courtesy GWB.)

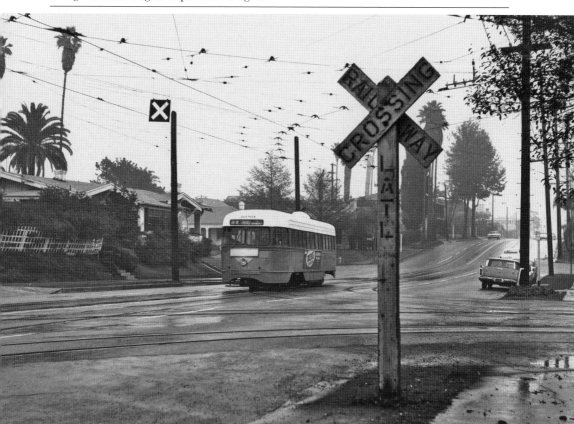

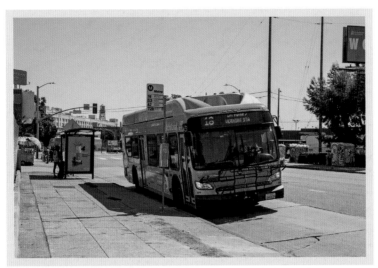

LAMTA discontinued trolleys on March 31, 1963, in favor of buses. Only two routes had electric trolleybus service, like 9040, shown days before becoming obsolete. This was an American Coach and Foundry–Brill TC-45, dating from 1948 and seating 44. These recycled coaches were used only a short time before being replaced with diesel buses. Now, Metro Local bus 6072 runs along Route 18 on South Central Avenue at Sixth Street. (Photograph by Roger Fogt, courtesy Pacific Railroad Museum.)

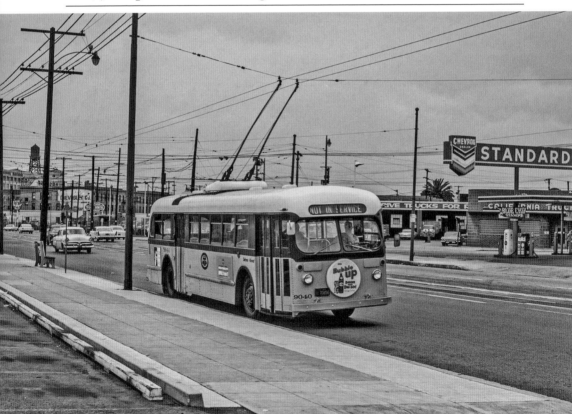

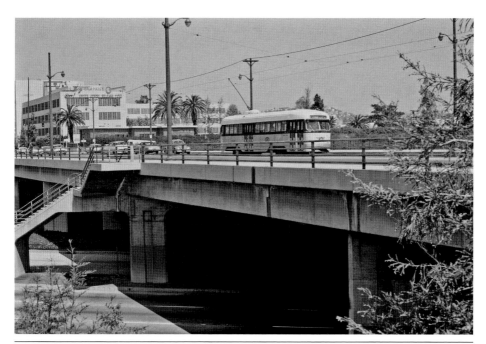

Just west of Silver Lake, one of our nation's first highways was commissioned in 1926 as US 101. On March 24, 1963, LAMTA car 3121 traveled the V-Line on North Vermont Avenue, days before trolley service would be halted. The original freeway bridge remains as does some of the commercial architecture as Metro Rapid articulated Bus 9572 heads south on the 745-Line. Metro Rapid Bus service might also soon be reimagined. (Photograph by Bruce Ward, MLPSI Collection, donated by Jim Kreider.)

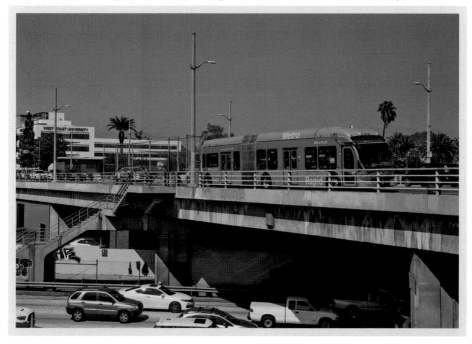

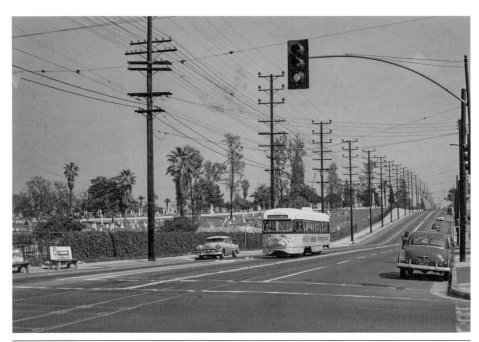

Fittingly, "crying" LAMTA PCC 3002 (see closeup on page 85) passes Evergreen Cemetery, westbound along East First Street at Evergreen Avenue, with "Goodbye Forever, Old Sweethearts and Pals" painted on its sides. This is the second-to-last day (March 30, 1963) before discontinuation of trolley service. Metro bus 8557 serves here today, stating "Wear a Face Mask Onboard" during the COVID-19 pandemic. Evergreen Cemetery opened in 1877 and is L.A.'s oldest. (Photograph by Bruce Ward, courtesy MLPSI, donated by Jim Kreider.)

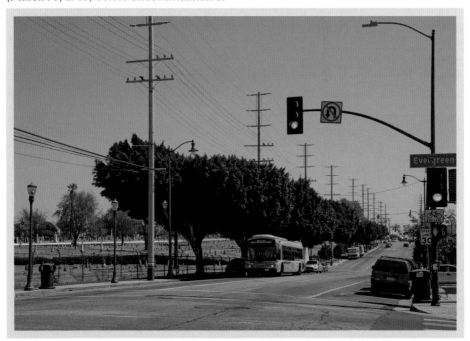

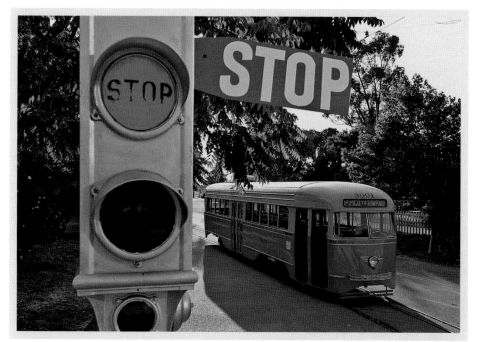

A survivor! LAMTA Special PCC car 3001, originally christened by actress Shirley Temple, would survive P-Line service following this fan trip photograph taken on November 18, 1962. Railroad enthusiasts knew the end of trolley service was near, so they took advantage of one of the last rides along original trackage. This car has been preserved with its original LARY paint scheme and is part of the Southern California Railroad Museum collection in Perris, California. (Photograph by Roger Fogt, courtesy Pacific Railroad Museum.)

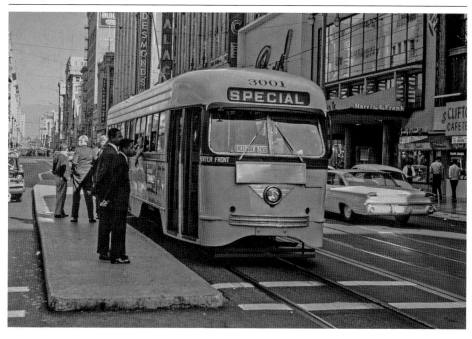

Discover Thousands of Local History Books
Featuring Millions of Vintage Images

Arcadia Publishing, the leading local history publisher in the United States, is committed to making history accessible and meaningful through publishing books that celebrate and preserve the heritage of America's people and places.

Find more books like this at
www.arcadiapublishing.com

Search for your hometown history, your old stomping grounds, and even your favorite sports team.

Consistent with our mission to preserve history on a local level, this book was printed in South Carolina on American-made paper and manufactured entirely in the United States. Products carrying the accredited Forest Stewardship Council (FSC) label are printed on 100 percent FSC-certified paper.

MADE IN THE USA